BASEBALL
IN NEWARK

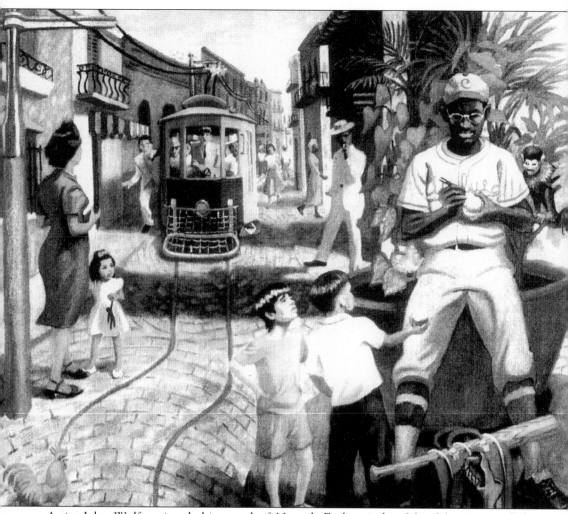

Artist John Wolfe painted this mural of Newark Eagles pitcher Max Manning in Cuba. Manning and other members of the Eagles participated in the Cuban and Latin American winter leagues. (Courtesy of John Wolfe.)

BASEBALL
IN NEWARK

Robert L. Cvornyek

First printed in 2003.

Published by Arcadia Publishing,
an imprint of Tempus Publishing Inc.
2A Cumberland Street
Charleston, SC 29401

Printed in Great Britain.

Library of Congress Catalog Card Number: 2003107821

For all general information, contact Arcadia Publishing:
Telephone 843-853-2070
Fax 843-853-0044
E-mail sales@arcadiapublishing.com

For customer service and orders:
Toll-free 1-888-313-2665

Visit us on the Internet at www.arcadiapublishing.com.

For my mother and the memory of my father for teaching me to respect Newark and all its people and for Robert, Elizabeth, and Dorothy.

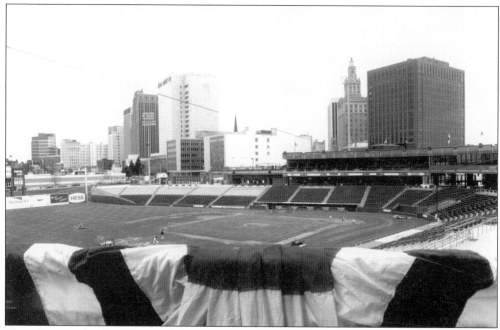

This photograph offers a view of the stadium and the city.

CONTENTS

ACKNOWLEDGMENTS

I wish to express my sincere respect and appreciation to the city's historian, Charles F. Cummings, for sharing his extensive knowledge of Newark during this project. He and the staff in the New Jersey Information Center at the Newark Public Library provided valuable assistance in locating and identifying many of the photographs in this book. I also want to thank Ellen Snyder-Grenier, the deputy director of special projects at the New Jersey Historical Society, for providing materials relating to the society's wonderful exhibit entitled *Pride of Newark: Baseball's Bears and Eagles*. James Lewis and Anna Helena Lubieniecka, also of the New Jersey Historical Society, offered valuable research assistance. Lawrence Hogan of Union County College permitted generous access to his voluminous collection of photographs and documents relating to the Newark Eagles. It was a pleasure to talk to him about the history of black baseball and share his enthusiasm for the subject. The Bears organization, especially Ross Blacker and Jim Cerny, shared their time and expertise in locating and explaining many of the photographs pertaining to the current Newark Bears. I also want to thank the Bears' photographers, Colin Burke, Kyle Burke, Gordon Forstyh, and Bill Lenahan, for permission to reproduce their work. The staff of the New Jersey Room at the Jersey City Public Library; David Kaplan, deputy director of the Yogi Berra Museum and Learning Center; the Photography Department at the National Baseball Hall of Fame; and Laurie Proulx of Rhode Island College assisted in providing images for the project. Lastly, I must thank Ron Dufour, a gifted writer and historian, but regrettably a Boston Red Sox fan, for reading and editing the manuscript.

INTRODUCTION

As a youngster growing up in Newark, all I heard from my parents and neighbors was the city's good old days of baseball. Their words left a lasting impression. I learned to respect the game and the city that helped so many families through the troubled years of the Great Depression and World War II. Baseball was a lifeline to the city. Two great teams, the Bears and the Eagles, played outstanding ball and thrilled fans across the city. Newark was the home of the Triple-A farm club of the New York Yankees, the farm club that produced local heroes and future major-leaguers, including Yogi Berra, Charlie Keller, Tommy Henrich, and Marius Russo. Most consider it the greatest minor-league franchise in history. In addition, the Negro League champion, the Newark Eagles, represented the city at the same time with equally remarkable success. The 1946 Eagles, with Hall of Famers Monte Irvin, Larry Doby, Willie Wells, Leon Day, and Ray Dandridge, ranks as one of the best teams ever assembled.

I am proud to say that professional baseball has returned to Newark since the golden era of the 1930s and 1940s. The new Bears of the Independent Atlantic League returned to town in 1999 and shortly thereafter captured the city's first championship in more than 50 years. The new Bears, and especially their new home field, Bears and Eagles Riverfront Stadium, honor the memory of the city's great players and teams and serve as a symbolic link to Newark's storied baseball past.

I am happy to report that Newark baseball now has a book of its own. This photographic essay begins when the city and the sport were experiencing growing pains, and it concludes with both enjoying a genuine sense of revival and renewal. It is a wonderful story, and author Robert L. Cvornyek tells it in a way that fans can appreciate and understand; it is clear he knows and admires the city and its rich baseball heritage. These photographs, some published for the first time, enliven, inform, instruct, but most importantly, compel us to remember the players and the teams that graced this city and its loyal fans.

—Rick Cerone
President-Owner, Newark Bears
Major-league player, 1975–1992

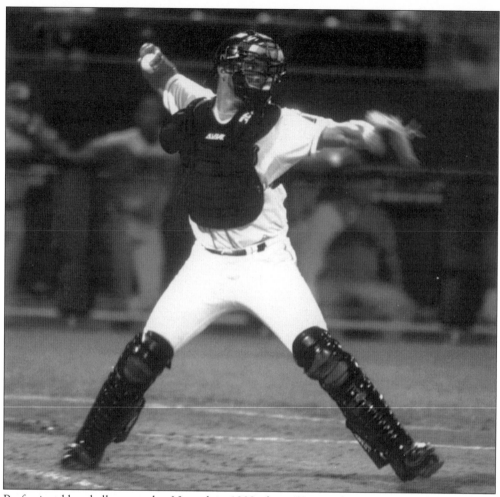

Professional baseball returned to Newark in 1999 after a 50-year absence. Newark Bears catcher Peto Ramirez symbolized the competitive spirit of the city and its baseball tradition.

One

BASEBALL FINDS A HOME
1855–1931

The baseball fans of Newark have always understood the game, its history, and the city's important role in shaping the national pastime. The common language of baseball, introduced by the city's gifted sportswriters and refined on street corners, kept fans informed and arguments lively. Shared language created shared memories that helped forge a sense of local identity for the different nationalities, races, and classes seeking opportunity in the region's hardest working city. Throughout the years, Newark's toughness and resilience demanded that its sports figures display the same grit and determination as the city. Newark fans have indeed been blessed with many of the finest players and teams representing amateur and professional baseball.

Newark's baseball tradition began in the decade preceding the Civil War. In the summer of 1855, one newspaper reporter noted that baseball had become "very popular among the young men" in Newark. Amateur teams, such as the Newark Club (New Jersey's oldest organized baseball team) and the Adriatics, competed in games against cross-bay rivals in Jersey City and Hoboken and cross-river clubs in Manhattan, including the Gothams, Eagles, and Empires. During the 1860s, no fewer than five teams—the Newark Club, Eurekas, Americus, Lafayettes, and Pioneers—represented Newark in amateur league play. The Eureka team, a mixture of blue-collar and white-collar players from across the city, outdistanced the other hometown clubs and captured the lion's share of wins and attendance. The Eurekas played in a stadium on Railroad Avenue but later moved to a field just south of Ferry Street near present-day Adams Street. According to one sportswriter, the brand of baseball played in Newark was so good after the Civil War that it produced two stellar players, "Sweasey an infielder and Leonard an outfielder," who started on the Cincinnati Red Stocking team that won an unprecedented 81 consecutive games in 1869. By the 1870s, the Eurekas were replaced by the Actives, a team that produced the city's first African American ballplayer, a man named O'Fake, and the Amateurs, who featured Sam Wright, a catcher talented enough to later enter the professional ranks.

A critical turning point in Newark's baseball history occurred in 1884, when the Domestics, a team sponsored by the city's Domestic Sewing Machine Company, elected to turn professional by joining the Eastern League, the forerunner of today's International Minor League. The Domestics lasted two years, enjoying a second-place and fourth-place finish in 1884 and 1885, respectively. This 12-man squad included future Hall of Famer Connie Mack, who according to *Sunday Call* sportswriter G.A. Falzer, "had left a shoe cobbler's bench in Brookfield Massachusetts to make his baseball debut in Newark." After changing its name to the Little Giants in 1886, the team presented Newark its first championship. The Little Giants finished first by a 16-game margin over Waterbury, Connecticut, riding the arm of "Phenomenal" John Smith, who averaged a dozen strikeouts per game.

The Newark Trunkmakers captured the city's second championship in the Central League in 1888, and the Colts delivered a third title in the Atlantic League in 1896. In 1913, Newark again won a minor-league championship, this time in the International League. According to historian Neil Sullivan, minor leagues and teams "came and went at a dizzying pace," and such

was the case in Newark. Prior to World War I, Newark would host seven different clubs (Domestics, Little Giants, Trunkmakers, Colts, Sailors, Indians, and Cubans) and belong to four different minor leagues (Eastern, Central, Atlantic, and International). It was also during this time that Newark achieved major-league status by affiliating with the "outlaw" Federal League. This league was created as a rival to the established National and American Leagues. Newark sponsored the Peppers, sometimes called the Feds, in 1915, but the team lasted only one year.

The Newark Bears' arrival in the International League in 1917 seemed to offer fans a sense of stability, but this was not the case. The team disbanded in 1919, returned to Newark under new ownership in 1921, and then temporarily left the city for Providence, Rhode Island, in 1925. The team returned home in 1926 and finally provided the stability Newark craved; it stayed in town until 1949. The Bears experienced limited success during the 1920s and early 1930s. The Bears' leadership, both on and off the field, contributed to the team's problems as the Bears suffered through a succession of managers and changed owners four times before 1931. Despite these drawbacks, fans witnessed impressive individual performances by Lew Fonseca, Bobby Stevens, Jocko Conlon, Charley Hargreaves, and Jim Weaver. At the close of the 1931 season, the New York Yankee organization purchased the franchise and quickly turned it into its premier farm team. As we shall see, the combination of Yankee leadership and resources would allow the Bears to achieve genuine greatness.

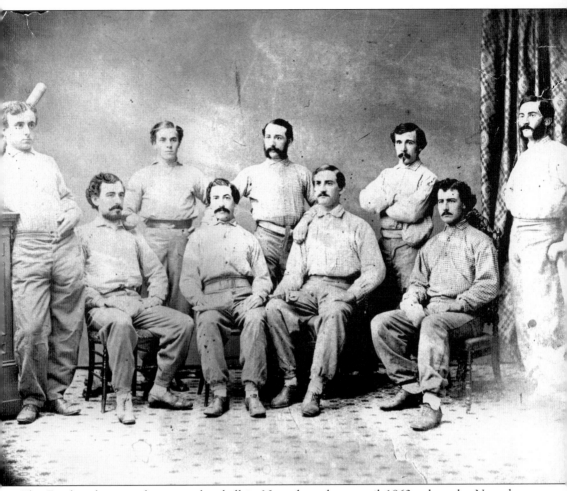

The Eurekas dominated amateur baseball in Newark, at least until 1863, when the *Newark Daily Advertiser* reported that the team had been "much weakened by the absence of many of their best members in the 26th Regiment and the Navy." The Civil War was the first but not the last time that Newark would sacrifice its ballplayers to the armed services. Pictured in 1860, these team members are Wesley Faitoute, pitcher; Heber Breintnall, catcher; Henry D. Northrup, first baseman; Edward Pennington, second baseman; Edward Mills, third baseman; Charles Thomas, shortstop; Frederick Calloway, left fielder; Albert Littlewood, center fielder; and ? Burroughs, right fielder. (Courtesy of the New Jersey Historical Society.)

	Put Out on Base A. Caught Flying B. Caught on Bound C.					INNINGS AND HANDS OUT.									Caught on Tip D. Struck Out E. Touched by F.	
No. and Position of Players	PLAYERS.	1	2	3	4	5	6	7	8	9	10	11	12	13	RUNS.	REMARKS.
	No. of Runs each Innings,	2	1	1	1	5	3	2	2	1					18	

1860 Umpire.

The Eurekas helped initiate the fierce competition between Newark and Jersey City. Perhaps the oldest scorecard depicting a Newark baseball team details this rivalry. The Jersey City Hamiltons hosted and defeated the Eurekas 35-18 in 1860. The following year, the Hamiltons' secretary-treasurer, N.B. Shufor, concluded that playing well against the Eurekas helped establish Jersey City's status as a first-rate ball club. (Courtesy of the Jersey City Public Library.)

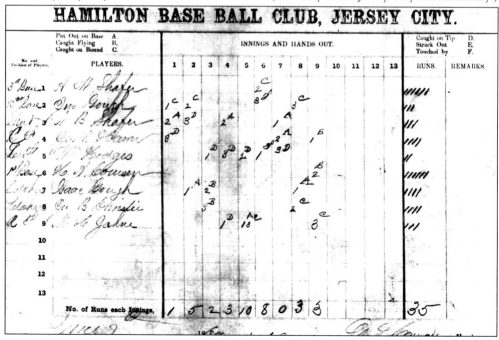

HAMILTON BASE BALL CLUB, JERSEY CITY.

	Put Out on Base A. Caught Flying B. Caught on Bound C.					INNINGS AND HANDS OUT.									Caught on Tip D. Struck Out E. Touched by F.	
No. and Position of Players	PLAYERS.	1	2	3	4	5	6	7	8	9	10	11	12	13	RUNS.	REMARKS.
	No. of Runs each Innings,	1	5	2	3	10	8	0	3	3					35	

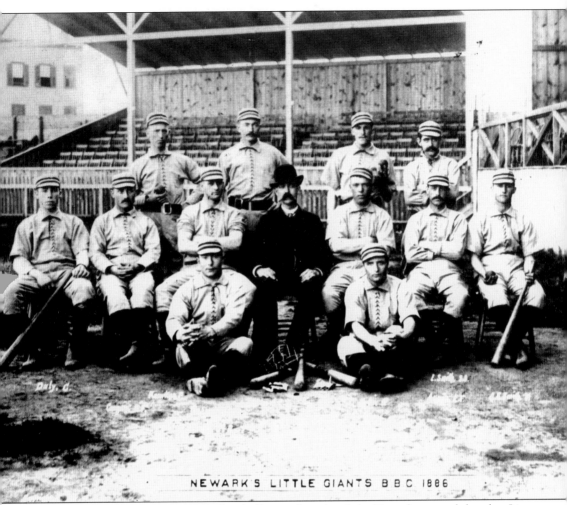

NEWARK'S LITTLE GIANTS B.B.C. 1886

Newark's reputation as New Jersey's baseball capital predated the Bears by several decades. In 1884, the Newark Domestics joined the Eastern League and became the city's first professional club. The team changed its name to the Little Giants at the start of the 1886 season. That year, the Giants posted a record of 68-26, captured the Eastern League title by 16 games, and presented the city its first championship. This photograph is the earliest image of Newark's storied professional baseball past. (Courtesy of the Newark Public Library.)

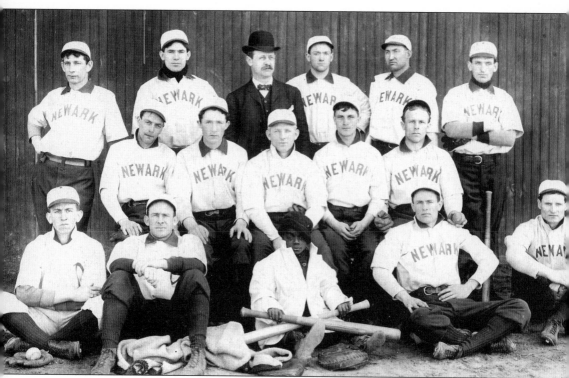

The Newark Sailors, named after the players' blue-and-white uniforms, represented Newark in the Eastern League from 1902 to 1907. The 1904 team, pictured here, achieved a franchise record of 77 wins against 59 losses. Two Sailors who enjoyed distinguished major-league careers were Matty McIntyre, outfielder on Detroit's three pennant-winning seasons, and Tim Jordan, home run king with Brooklyn. (Courtesy of the Newark Public Library.)

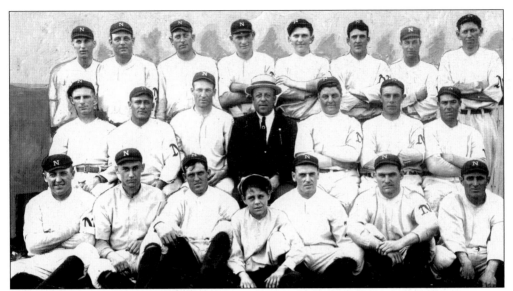

The Newark Indians' championship team of 1913 includes, from left to right, the following: (front row) Ducky Holmes, pitcher; Johnnie Enzmann, pitcher; Bob Higgins, catcher; an unidentified mascot; ? Gagnier, shortstop; Hi Myers, center fielder; and Eddie Zimmerman, third baseman; (middle row) Jerome Nusbaum, secretary; Billie Zimmerman, left fielder; Jack Dalton, right fielder; George Solomon, president; Harry Smith, manager; Raleigh Aitchinson, pitcher; Wyatt Lee, pitcher; (back row) Al Schacht, pitcher; George Bell, pitcher; Harry Swacina, first baseman; Beanie Hall, pitcher, Lew McCarthy, catcher; Gus Getz, second baseman; Bert Tooley, shortstop; and Cy Barger, pitcher. The team might have repeated as champions in 1914, but Bears owner Charles Ebbets Sr. ordered key players to join his National League Brooklyn Dodgers. (Courtesy of the Newark Public Library.)

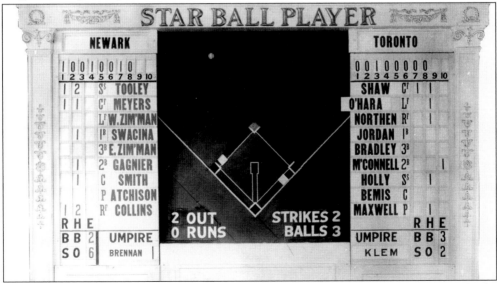

After the 1913 season, the Star Ball Player Company of New York, in partnership with the Alexander Traud Manufacturing Company in Newark, proposed this model scoreboard for the Indians. Once outside the stadium, the *Newark News* kept fans posted by displaying inning scores on a huge board in front of the newspaper's office. (Courtesy of the New Jersey Historical Society.)

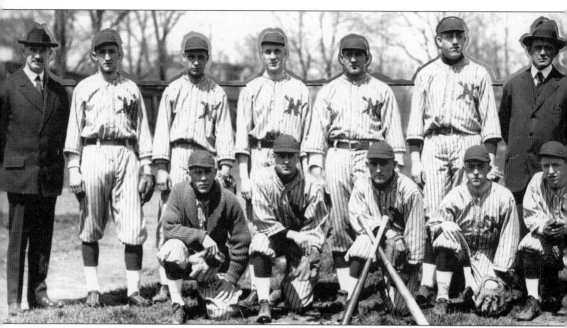

Following the end of Federal League play in 1915, minor-league baseball recaptured center stage. The Indians are seen here on opening day in 1916. From left to right are the following: (front row) Thaler; Walzer; Bruesch; Camp; and Reilly; (back row) Newark police commissioner John Reid, who threw the inaugural pitch; Bush; Van Ness; McGuire; Schenck; Miner; and Fred Tenney, manager. (Courtesy of the Newark Public Library.)

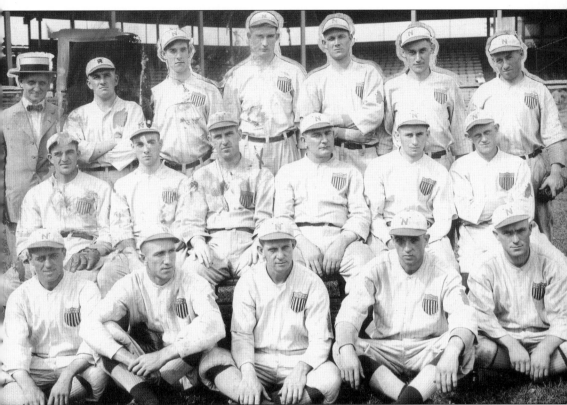

The Bears officially entered the International League in 1917 and remained until 1919. From left to right are the following: (front row) Leo Callahan, Clarence Russell, Jack Lewis, Sam Ross, and Howard Camp; (middle row) Gus Getz, Fred Blackwell, Ben Egan, Tom Needham, Elmer Brandel, and Frank Fuller; (back row) E.W. Wicks (business manager), George ?, ? Wilkinson, Bruno Haas, Bob McGraw, Walter Smallwood, Johnnie Enzmann, and Ross Eldred. (Courtesy of the Newark Public Library.)

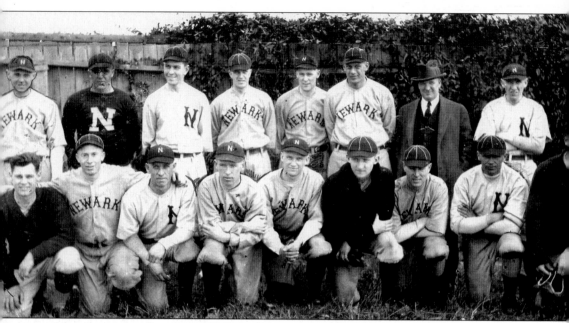

After a one-year absence in 1920, the Bears returned under new management in 1921. They remained in Newark until the middle of the 1925 season and then temporarily moved to Providence, Rhode Island. The 1923 team assembled at its home field, Harrison Field, for this photograph. (Courtesy of the Newark Public Library.)

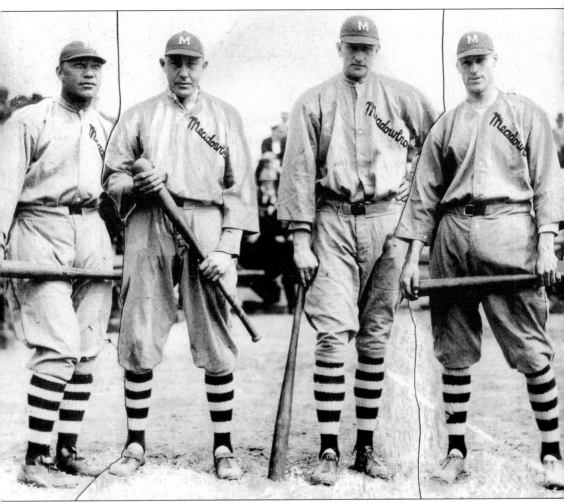

When Harrison Field was destroyed by fire, the Bears shared Asylum Oval in Newark with the city's popular semiprofessional team, the Meadowbrooks. These players from the 1923 Meadowbrooks are, from left to right, Marty Kavanaugh, Peter Krumenaker, Rupe Mills, and Jimmy Heath. (Courtesy of the Newark Public Library.)

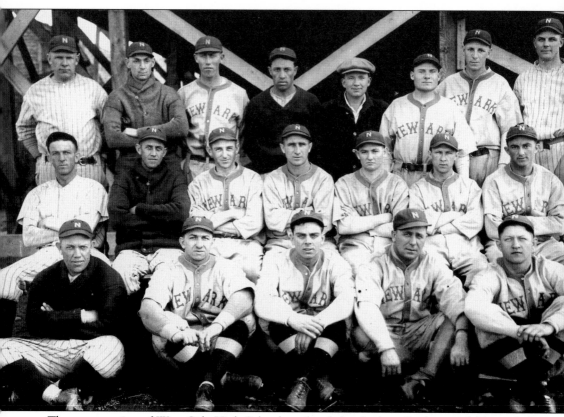

The construction of West Side High School rendered the Asylum Oval unavailable, and the 1925 Bears, pictured here, moved to Rhode Island as the Providence Grays. (Courtesy of the Newark Public Library.)

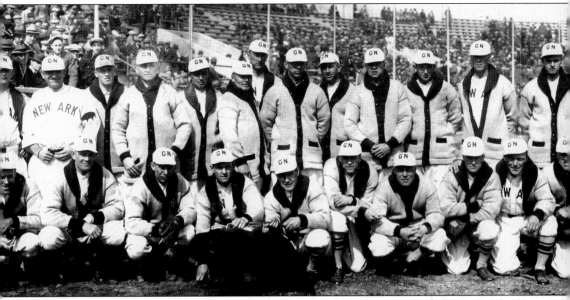

The 1926 Bears are, from left to right, as follows: (front row) Fonseca, Smallwood, Batch, Watl, Kennedy, Dwyer, Burns, Gagnon, Lepard, and Hawks; (back row) Zubris, Clarke, Wilson, McCarty, Brown, Burchell, Schreiber, Schroder, Shorten, Mamaux, Kane, Hankins, and Adams. (Courtesy of the Newark Public Library.)

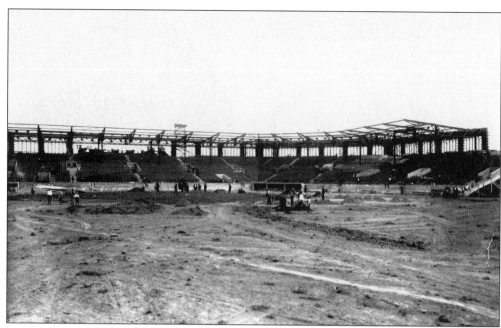

Bears owner Charles L. Davids purchased a plot of land for a reported $125,000 on Wilson Avenue in Newark's immigrant "Ironbound" neighborhood, where he erected the Bears' permanent stadium. Prior to purchasing the Bears, Davids was a successful semiprofessional baseball promoter from Bayshore, Long Island. (Courtesy of the Newark Public Library.)

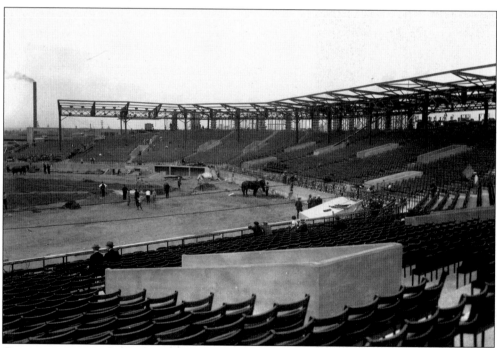

Construction crews, led by horse-drawn wagons, worked hard to have Davids Stadium ready for opening day, but delays pushed the stadium's official opening to May 15, 1926. The fences down both lines measured less than 250 feet. (Courtesy of the Newark Public Library.)

Before beginning his major-league career with the National League New York Giants in 1925, Blackie Carter played outfield for the Newark Bears. (Courtesy of the Newark Public Library.)

Joe Zubris was a hard-throwing right-handed pitcher for the Bears during the 1920s. In 1925, he won 19 of his last 21 games. (Courtesy of the Newark Public Library.)

Joe Dwyer, pictured in 1927, was a hometown favorite who remained with the Bears organization throughout most of his professional career. (Courtesy of the Newark Public Library.)

Dwyer anchored the Bears outfield between 1943 and 1944. According to Larry Keefe, former Seton Hall University sports information director, Dwyer "was born too soon and got his chance in the major leagues too late in his career." He retired in 1945. (Courtesy of the Newark Public Library.)

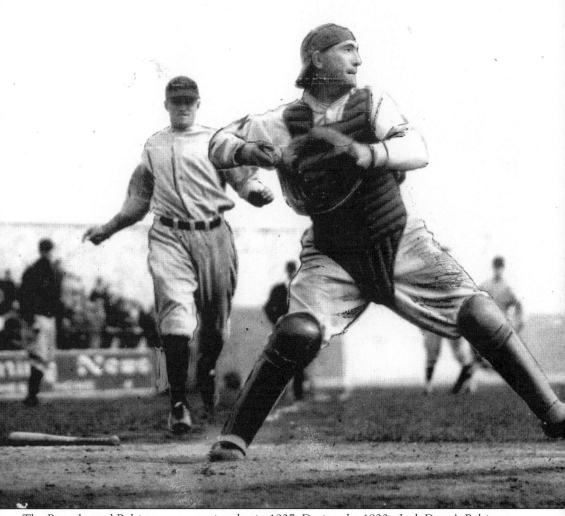

The Bears hosted Baltimore on opening day in 1927. During the 1920s, Jack Dunn's Baltimore Orioles featured many of the game's best minor-league players. The Orioles dominated International League play by winning seven consecutive pennants between 1919 and 1925. Dunn had the good sense to sign pitcher Babe Ruth to a contract in 1914. The Bears-Orioles contests were popular ones with Newark fans. (Courtesy of the New Jersey Historical Society.)

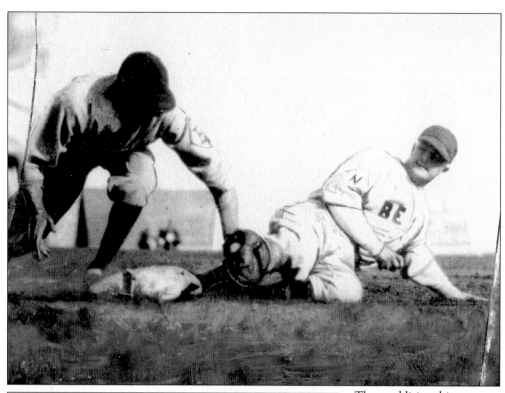

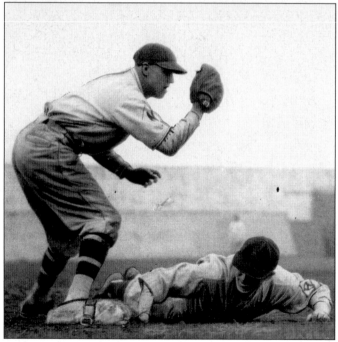

These additional images from the Bears-Orioles 1927 opener represent two of the earliest action photographs taken of Newark players. Newspaper photographers were allowed on the field to capture the action in order to enliven sports coverage in local papers. (Courtesy of the New Jersey Historical Society.)

On October 14, 1927, Bears owner Paul Block signed one of baseball's greatest pitchers, Walter Johnson, to a two-year contract as manager. Johnson's presence stimulated interest in the team, but the Bears posted a losing 81-84 record in 1928. Johnson, looking to manage in the majors, left Newark after only one season to pilot the Washington Senators. (Courtesy of the Newark Public Library.)

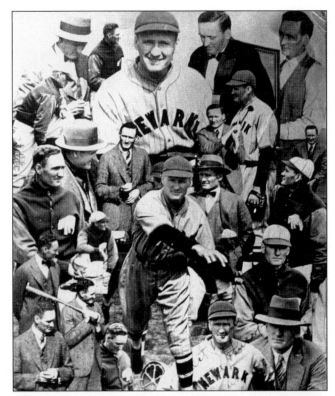

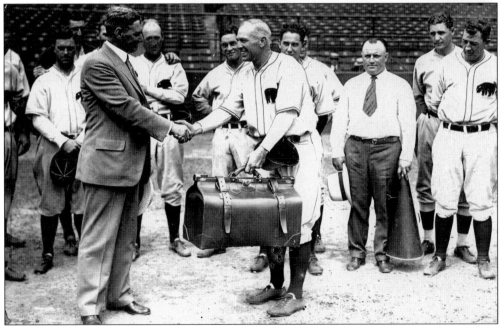

After finishing his Hall of Fame career in 1928, mostly with the Boston Red Sox and Cleveland Indians, outfielder Tris Speaker joined the Newark Bears as a manager. Newark commissioner John Howe presented Speaker with a traveling bag at the start of the 1929 season. (Courtesy of the Newark Public Library.)

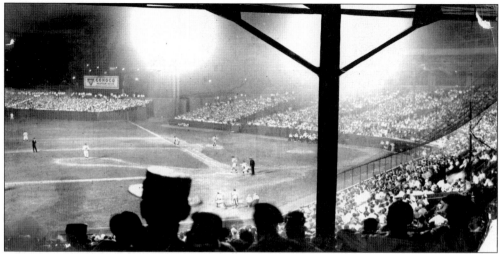

On August 7, 1930, nearly 15,000 fans crowded Davids Stadium to watch the Bears' first night game in Newark. Night games offered the city's working men and women an opportunity to support their team and enjoy an evening's entertainment. Toronto defeated Newark 8-6. (Courtesy of the Newark Public Library.)

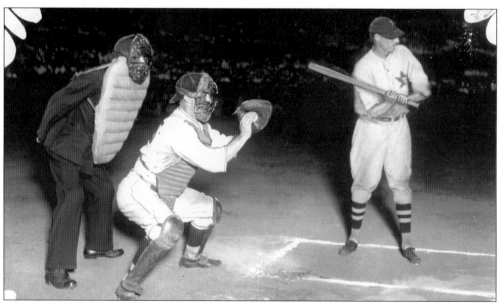

A Toronto batter squares for a pitch during the Bears' first night game in Newark. Just weeks before, on July 24, 1930, the Bears battled the Jersey City Giants in the first professional night game in New Jersey. (Courtesy of the Newark Public Library.)

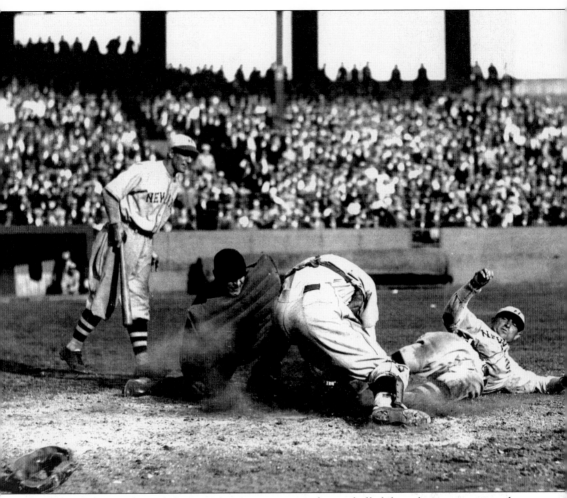

The Bears participated in exhibition games against major-league ball clubs to boost revenue and entertain fans during the Great Depression. In this game, the Philadelphia Phillies defeated Newark 4-3. (Courtesy of the Newark Public Library.)

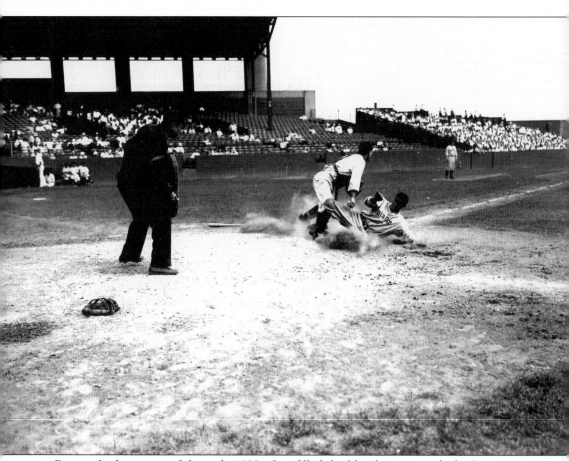

During the lean years of the early 1930s, fans filled the bleachers to watch the Bears compete against the Buffalo Bisons. (Courtesy of the Newark Public Library.)

Two

NEWARK'S PINSTRIPE TRADITION

1932–1949

During the difficult years of depression and war, Newark's fans enjoyed watching one of the most successful minor-league teams in baseball history. In 1931, Jacob Ruppert, owner of the New York Yankees, purchased the Bears from financially strapped newspaper editor Paul Block for an estimated $600,000. The acquisition included Davids Stadium, a relatively new park built in 1926 and located on Wilson Avenue in the city's East Ward, or Ironbound, neighborhood. The ballpark was renamed Ruppert Stadium shortly after the Yankee takeover. According to historian Neil Sullivan, Ruppert, who amassed a fortune in his father's beer business and later in real estate, wisely surrounded himself with men who knew the game. In particular, he persuaded George Weiss, vice president and general manager of the Baltimore Orioles, to accept an offer to run the Newark club and build a minor-league system for the Yankees.

Weiss remained with the Yankee organization for 28 seasons, from 1932 to 1960, serving as architect of the farm system and Yankee general manager. By 1940, New York controlled nine minor-league teams operating at all levels of competition. Newark, the crown jewel of the Yankee system, consistently developed talent for the parent organization, allowing it to win seven American League pennants between 1936 and 1943. During the Bears' 18-year existence in Newark, the team finished atop the International League in 1932, 1933, 1934, 1937, 1938, 1941, and 1942. The Bears also advanced to the league playoffs an additional nine times, missing only the 1947 and 1949 seasons. The team defeated its playoff rivals in 1937, 1938, 1940, and 1945 and captured the Little World Series crown in 1932, 1937, and 1940.

Understandably, it was the 1937 ball club that received the most praise and attention. Recently named the minor-league team of the century by the readers of the publication *Baseball America*, the 1937 Bears remain fixed in the city's collective memory. According to New Jersey baseball historians Ronald Meyer, James DiClerico, and Barry Pavelec, the greatness of this celebrated team rested on three achievements. First, Newark finished an astonishing 25½ games in front of the International League's second-place team, the Montreal Royals. Second, the Bears captured the minor-league championship by defeating the Columbus Red Birds of the American Association in dramatic style. After losing the first three games, the players stormed back to win the last four to capture the Little World Series title. Finally, the team sent every starter to the major leagues. Among the regular players who graduated to the big league were Joe Gordon, Babe Dahlgren, George McQuinn, Jim Gleeson, Bob Seeds, Nolen Richardson, Buddy Rosar, Atley Donald, Joe Beggs, Vito Tamulis, and Steve Sundra. The most beloved member of the Newark squad, Charlie "King Kong" Keller, would play 13 seasons, mostly with the Yankees, and help comprise New York's most famous outfield of Joe DiMaggio, Keller, and Tommy Heinrich. In later years, major-league stars such as Yogi Berra, Bobby Brown, Johnny

Lindell, George Sternweiss, and Hank Madjeski advanced to the majors after starting their careers in Newark.

At the time the Bears opened their inaugural season in 1932, Newark was an immigrant, working-class city. Dubbed the "city of opportunity," Newark had the "vaunted reputation of producing almost anything," according to a popular guidebook of the city. However, most immigrants and their children worked in nearby factories and machine shops producing such things as steel, machine parts, clothing, paint, beer, and leather goods. While most foreign-born immigrants spent their leisure time in their own neighborhoods, their sons and daughters preferred to venture beyond local boundaries. Newark sportswriter Jerry Izenberg recalled that as a kid he rode a "carbon-monoxide-belching" bus down Wilson Avenue to Ruppert Stadium, where he encountered others from various sections of town. Collectively known as the "Knot-Hole Gang," youngsters from around the city formed a common identity based on the symbols, rituals, and language of Bears baseball. Izenberg also recognized the power of baseball in creating a cohesive popular culture among the city's diverse ethnic groups. He remembered that on summer nights, "you could pick a block in the city—any block—and in a world without air-conditioning, you could hear the sound of Earl Harper's play-by-play through the open windows, walk the length of that block and not miss a pitch." Similarly, *Trenton Times* reporter Harvey Yavener wrote that "for those of us who grew up in Newark during the Depression and the War, there was only one sports team . . . the Newark Bears."

On January 12, 1950, Newark fans experienced the unthinkable when the Yankees sold the franchise to the Chicago Cubs, who promptly moved the team to Springfield, Massachusetts. Kansas City now hosted the Yankees' Triple-A affiliate. George Weiss, the man who built the Yankee dynasty with Newark's muscle, officially cited lack of attendance as the reason for the sale. Sportswriters and historians still debate the reasons for the Bears' demise. Was it competition from the New York teams, now more easily accessible by car and rail? Or was it the live television broadcasts of Yankee, Dodger, and Giant games that kept fans away from Ruppert Stadium? Perhaps it was the Yankees decision to "raid" the Newark club for quality players during midseason that disenchanted fans and prevented the Bears from remaining competitive in International League play? Whatever the case, Newark would have to wait another 50 years before the Bears would again grace the city that worshiped baseball with what Jerry Izenberg called "semi-religious devotion."

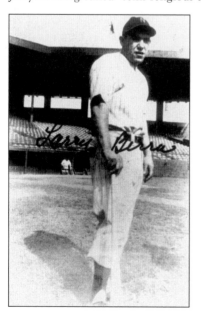

Lawrence "Yogi" Berra joined the Newark Bears as a 21-year-old catcher in 1946. Berra's storied career in Newark and later with the New York Yankees makes him the strongest symbol of the Bears-Yankees connection. Berra remarked, "I loved Newark. I enjoyed just playing there." After completing the Bears' 1946 season, Berra and fellow teammates Bobby Brown, Jerry Coleman, and Vic Raschi debuted with the Yankees. Berra anchored the legendary Yankee teams of the late 1940s, the 1950s, and the early 1960s. (Courtesy of the Yogi Berra Museum and Learning Center.)

In its first season under Yankee control, the Bears captured the International League pennant and then defeated Minneapolis in the Little World Series. This newspaper composite includes the team picture. From left to right are Wilber Crelin, Bears secretary; George Weiss, Yankees general manager; Al Mamaux, former Bears pitcher and manager; Charles H. Knapp, International League president; and Jacob Ruppert, Yankees owner and president. (Courtesy of Lawrence Hogan.)

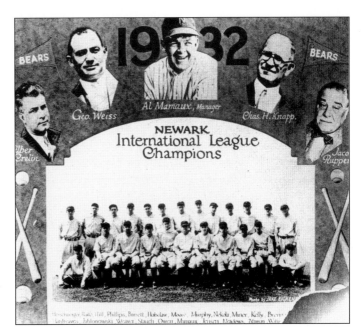

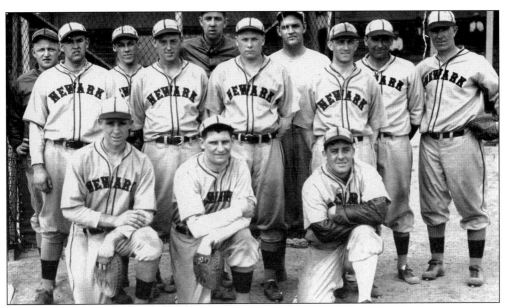

The 1932 Bears pose at the beginning of spring training in Seabring, Florida. Newark's annual preseason trip south started in 1908, when owner George Stallings took the team to Haddock, Georgia, where he owned a plantation. Johnny Neun, who played on the 1932 team and later became a popular Bears manager, cited shortstop Red Rolfe for his leadership and ability and credited the team's overall success to "good balance, speed, and hitting." (Courtesy of the Newark Public Library.)

Marvin Owen strengthened the Bears' infield upon his acquisition from the Detroit Tigers in June 1932. Considered the best fielder in the International League, Owen started the 1931 season at shortstop with the Tigers.

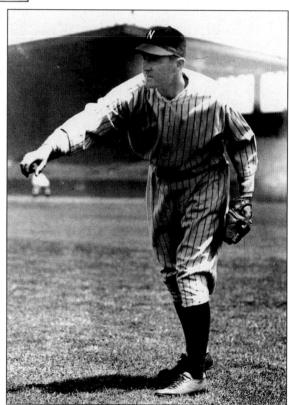

Johnnie Welsh was a pitcher for the 1932 championship team. (Courtesy of the Newark Public Library.)

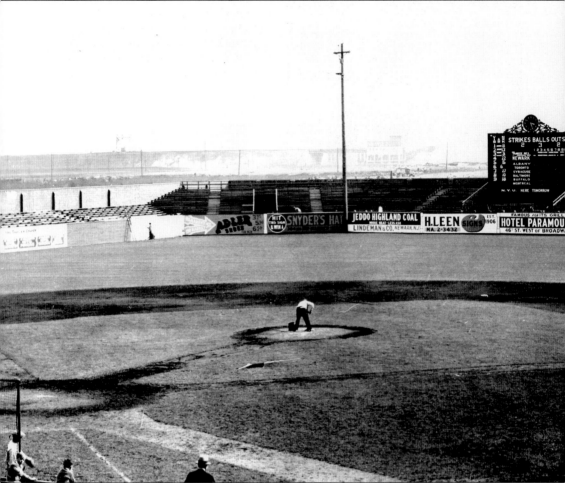

The Bears organization offered much needed jobs to Newark residents during the Great Depression. The employee roster included a public address announcer, trainer, bat boys, ushers, scoreboard keepers, press-box attendants, ticket managers, concessionaires, and groundskeepers like the one pictured here preparing the field for play in 1934. (Courtesy of the Newark Public Library.)

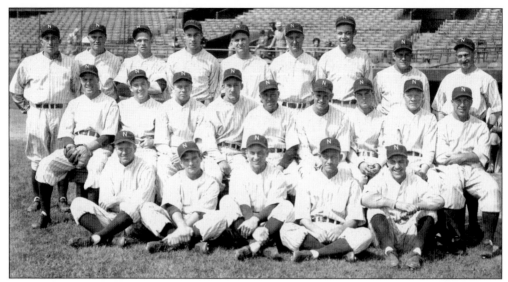

The 1936 Newark Bears are, from left to right, as follows: (front row) Marvin Duke, Frank Hawkins, Kemp Wicker, Nolen Richardson, and Ray Schalk; (middle row) Howard LaFlamme, Les Lowers, Cecil Spittler, Al Pichota, Oscar Vitt, John McCarthy, Willard Hershberger, Spurgeon Chandler, and Chief Kay; (back row) Max Rosenfeld, Merrill May, Bob Collins, Ray White, Bill Baker, Frank Makosky, Bob Muller, Dick Porter, and Ralph Boyle. The Buffalo Bisons defeated Newark in the International League playoffs four games to one. (Courtesy of the Newark Public Library.)

Shown is a Newark scorecard used at all home games during the 1936 season. An inside advertisement reminded fans to listen to Earl Harper, a well-known sports commentator, who broadcast Bears games over metropolitan radio station WINS.

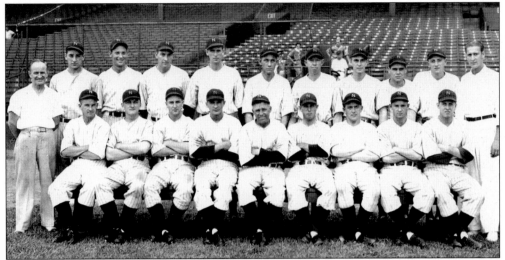

The 1937 Bears "Wonder Team" includes, from left to right, the following: (front row) Jimmie Mack (trainer), George McQuinn, Jimmie Gleeson, Francis Kelleher, Joe Beggs, Oscar Vitt (manager), Willard Hershberger, Vito Tamulis, Joe Gordon, Buddy Rosar, and Joe Fixter (announcer); (back row) Marius Russo, Steve Sundra, Phil Page, Jack Fallon, Nolen Richardson, Bob Seeds, Babe Dahlgren, Charlie Keller, and Atley Donald. (Courtesy of the Newark Public Library.)

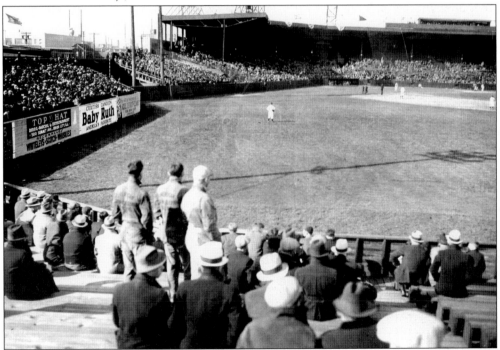

The city's working men and women pack the right-field bleachers for an afternoon game on opening day, April 22, 1937. Ronald Mayer's wonderful account of the Bears' legendary 1937 season reminds readers that opening-day activities included parades, music by Joe Basile's band, a detachment of soldiers, and various city politicians. The Bears defeated the Dodgers' farm club, the Montreal Royals, 8-5. (Courtesy of the Newark Public Library.)

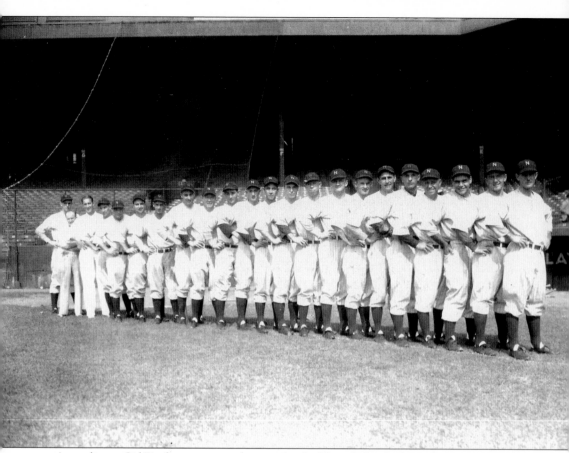

According to Sid Dorfman, sports columnist for the Newark *Star Ledger*, "the 1937 Newark Bears rated easily the greatest minor league team that ever existed. . . . For goodness sakes, in the course of a few years they practically replaced the Yankees." (Courtesy of the Newark Public Library.)

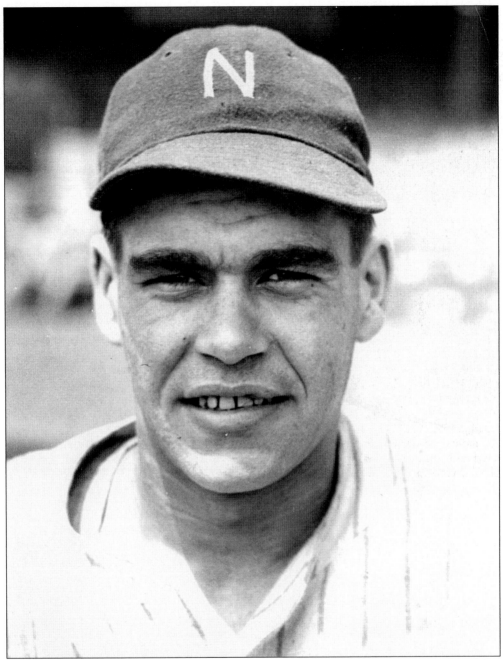

Charlie "King Kong" Keller won the admiration and affection of Newark fans for his hard play, dignified personality, and dedicated work ethic. Keller played in Newark in 1937 and 1938, before joining the Yankees for his rookie season in 1939. While in Newark, Keller helped the Bears capture two league championships, won the batting title for two consecutive years, and received the International League's Most Valuable Player (MVP) award sponsored by the *Sporting News*. Keller would play 13 major-league seasons, mostly with the Yankees, where he joined Joe DiMaggio and Tommy Henrich to comprise New York's most famous outfield. (Courtesy of the Newark Public Library.)

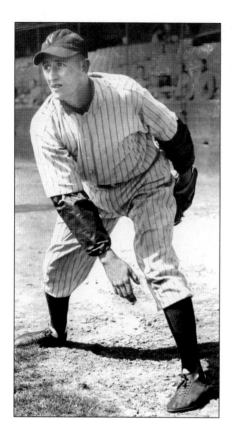

Atley Donald won 14 consecutive games en route to an astonishing 19-2 record for the 1937 Bears. Most contemporary fans agreed that the team won the championship on the strength of Donald's remarkable and reliable pitching. (Courtesy of the Newark Public Library.)

First baseman George McQuinn provided much of the power for the 1937 team. He hit 21 home runs and drove in 83 runs. In 1947, he returned to the Yankee organization after several successful seasons with the lowly St. Louis Browns and Philadelphia Athletics. (Courtesy of the Newark Public Library.)

Spurgeon "Spud" Chandler, journeyman right-handed pitcher, played for the Bears during the mid-1930s. He started the 1937 season in Newark but boarded a train to New York in midseason. He enjoyed a 10-year career with the Yankees from 1937 to 1947. Chandler won 20 games in 1943 and again in 1946. (Courtesy of the Newark Public Library.)

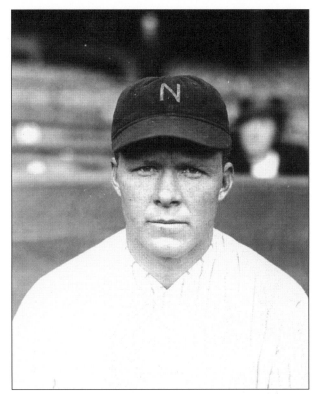

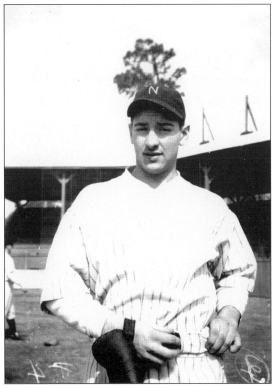

Left-hander Marius Russo saw limited action in 1937 but posted an impressive 17-8 record in 1938 to lead the Bears to yet another league championship. The Brooklyn-born Russo married Newark native Stasia Syndek. The couple had met after a Newark-Rochester game at Ruppert Stadium. (Courtesy of the Newark Public Library.)

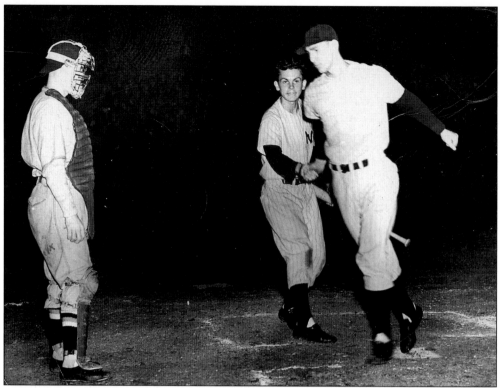

Mike Chartak crosses home plate after hitting a home run to break the ice in a scoreless game against Rochester in the 1938 playoffs. The Bears won the game 9-0 and then defeated the Red Wings in the first round of championship play.

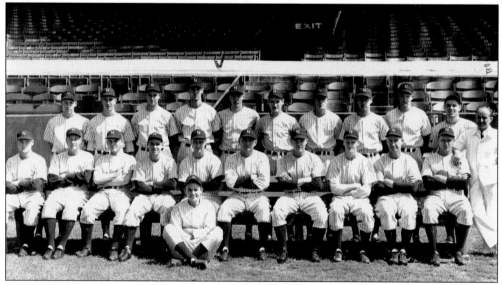

Although the 1940 Bears finished in second place behind the Rochester Red Wings, they won the league playoffs, advanced to the Little World Series, and defeated Louisville of the American Association for the minor-league championship. Each player received a $350 bonus for his effort. (Courtesy of the Newark Public Library.)

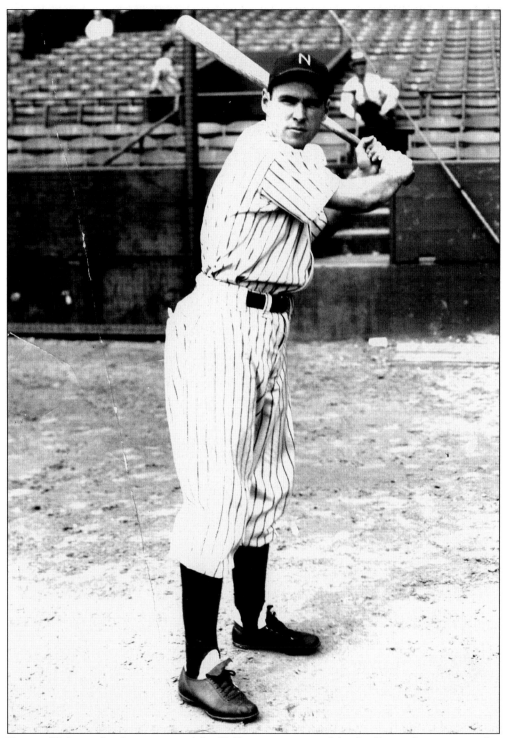

Tommy Holmes, the slugging star of the 1940 team, was one of the few Bears players not to play for the Yankees. After leaving Newark, he became a standout player with the Boston Braves. (Courtesy of the Newark Public Library.)

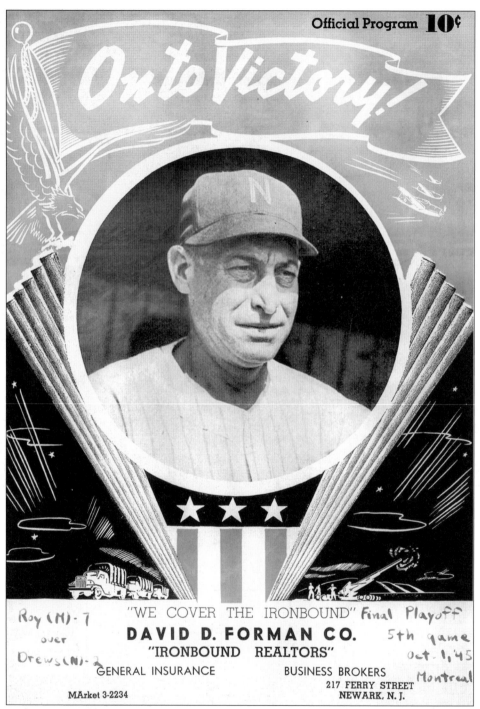

On to Victory!

"WE COVER THE IRONBOUND"
DAVID D. FORMAN CO.
"IRONBOUND REALTORS"
GENERAL INSURANCE

MArket 3-2234

BUSINESS BROKERS
217 FERRY STREET
NEWARK, N. J.

Roy (N) - 7
over
Drews (N) - 2

Final Playoff
5th game
Oct. 1, '45
Montreal

Bears manager Billy Meyer graces the cover of the team's patriotic 1945 program. The cover urges the Bears, but more importantly the nation, "on to victory" during World War II. An inside message entitled *Baseball and the War* concluded that "by continuing baseball, by keeping our spirits and morale high, we show Hitler and Hirohito we know how to win a war just as much as we show him this when our bombs blast Berlin."

Jackie Robinson, Montreal's second baseman, shattered Newark's color line in professional baseball on April 21, 1946. More than 13,000 fans, many of whom were African American, welcomed Robinson without incident. The Bears swept the Royals in an afternoon doubleheader. (Courtesy of the Newark Public Library.)

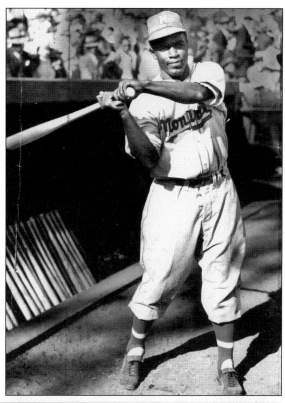

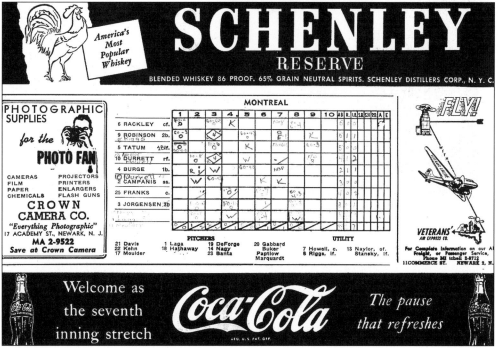

This 1946 Bears scorecard commemorates one of Jackie Robinson's historic visits to Ruppert Stadium.

In 1947, the franchise celebrated 15 years of Yankee ownership by highlighting the Bears' past achievements, which included several championship seasons. Newark proved that "no other team in the minor league can match this record," by posting the 15-year cumulative International League standings, which showed the Bears far ahead of its rivals.

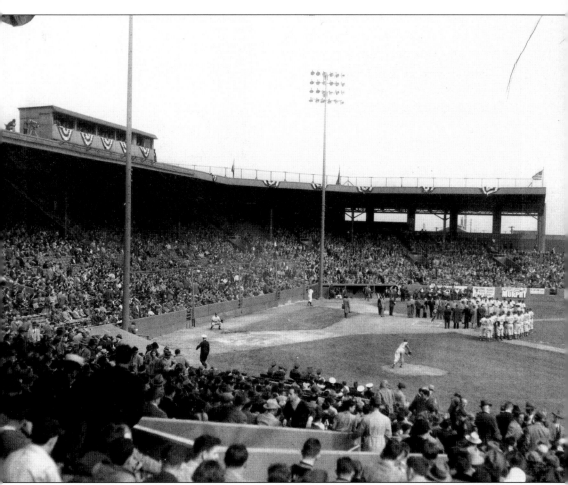

On opening day in 1949, the Bears commenced their final season in Newark. The Yankees placed the team on sale in the winter of 1948, but the Chicago Cubs waited a full year before purchasing the club. According to Bears historian Randolph Linthurst, the Yankees must "take some of the blame" for the team's poor performance and consequent drop in attendance. Linthurst observed, "Attendance was steadily rising in 1948 when Bob Porterfield was having a sensational year. When the Yankees recalled Porterfield, however, many fans felt betrayed and stopped coming to the park. The poor team sent by the Yankees in 1949 was the final nail in the coffin." (Courtesy of the Newark Public Library.)

Memories of the Bears and Ruppert Stadium remain fixed in the minds and hearts of fans and players. In 1969, Steve Picyk of Kearny, New Jersey, sent a letter to the *Newark Sunday News*, stating, "On a warm Sunday Afternoon I drove to the site of the ballpark looked out over the vacant acreage, and was flooded with memories. I recalled coming home from school, making a quick change and scampering to the stadium, where we sneaked past the cop at the gate and watched the last few innings of the Bears' games."

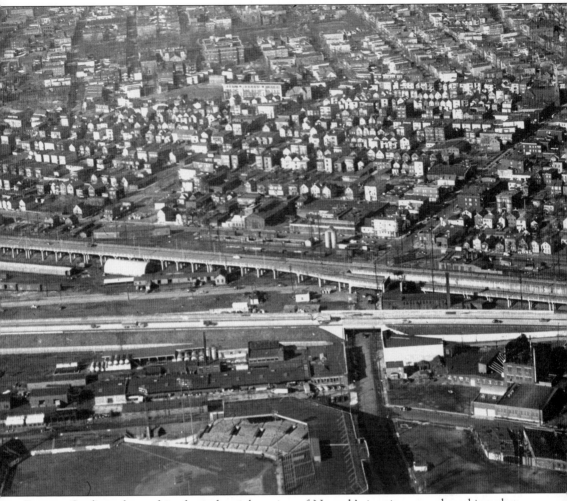

Ruppert Stadium, located in the industrial section of Newark's immigrant and working-class Ironbound neighborhood, stood tall amid the factories and rail yards as a symbol of Newark's role as the city of opportunity. (Courtesy of the Newark Public Library.)

Bears fans enjoyed a close relationship with the players both on and off the field. Before and after games, players frequently talked to fans, signed autographs, and posed for photographs. Photographs include this 1941 image of pitcher Hank Borowy.

This 1941 photograph shows, from left to right, outfielder Leo Nonnenkamp, infielder Don Lang, and shortstop George Scharein.

These players are, from left to right, first baseman Joe Mack, pitcher Walter Stewart, and catcher Ken Sears. The photograph was taken in 1941.

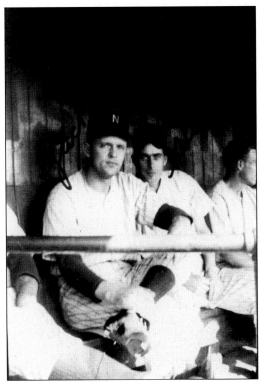

Pitchers Jack "Hack" Haley (left) and George Washburn are shown here in 1941.

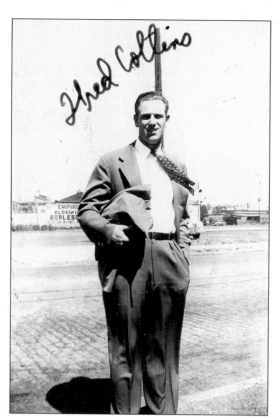

Fred Collins, utility infielder, is pictured in a 1941 photograph.

Shown in 1942 is outfielder Frank Kelleher.

George "Snuffy" Stirnweiss, shown in 1943, played second base.

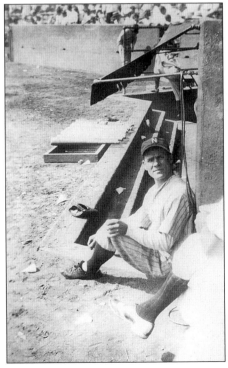

This 1945 photograph features pitcher Pete Appleton (Jablonowski).

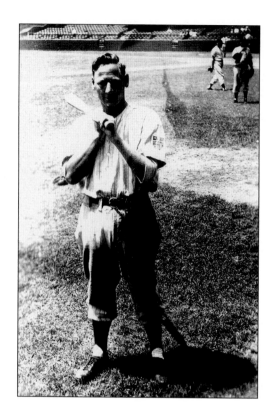

Frank Hiller, pitcher, poses in 1945.

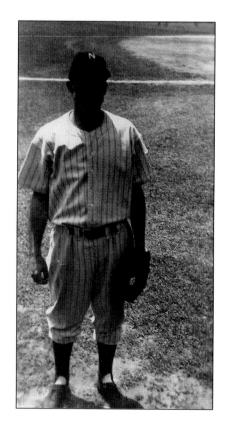

Seen in a 1946 photograph is Ken Holcombe, pitcher.

Shown is outfielder Milt Byrnes in 1946.

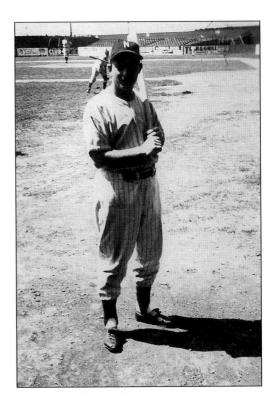

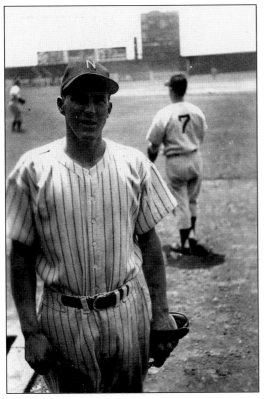

Third baseman George Savage is shown in 1947.

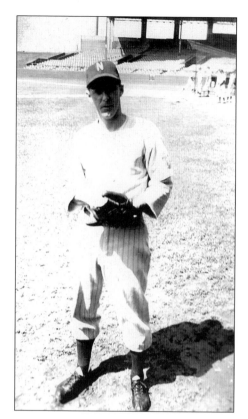

Steve Peek, pitcher, is pictured in a 1947 view.

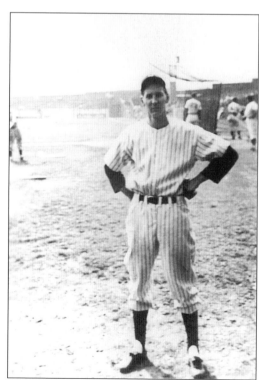

This photograph from 1947 shows first baseman Ed Levy.

Manager George Selkirk smiles from the dugout in this 1947 photograph.

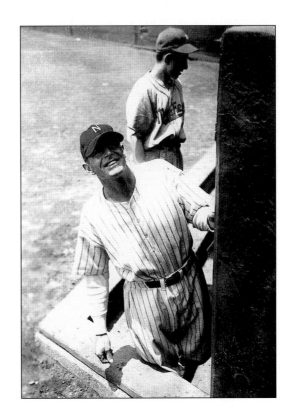

Posing in this 1947 view is pitcher Duane Pillette.

Al Clark, outfielder, is shown here in 1947.

Seen in this 1947 photograph is
Herb Karpel, pitcher.

Mike Etten, seen in 1947, played
first base.

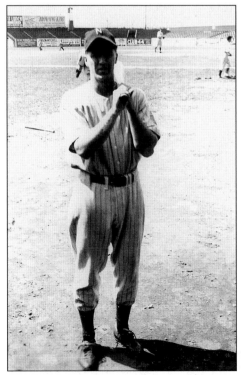

Shortstop Bobby Brown is shown in 1947.

Pictured in this 1947 photograph is Ted Sepkowski, outfielder.

Johnny Lindell, outfielder and first baseman, is captured in this 1947 view.

The 1938 Newark Bears

Standings

Team	W	L	Pct.
Newark Bears	109	48	.684
Syracuse Chiefs	87	67	.565
Rochester Red Wings	80	74	.519
Buffalo Bisons	79	74	.516
Toronto Maple Leafs	72	81	.471
Montreal Royals	69	84	.451
Jersey City Giants	68	85	.444
Baltimore Orioles	52	98	.347

Player Profiles

Newark fans thrilled at the exploits of the 1937 "Wonder" Bears, but who remembers the 1938 team? At the end of the 1938 season, the Bears' publicity department issued biographical sketches of the players:

John Haley, pitcher. Born Broad Fords, Pa., October 3, 1914. Bats and throws right. Weight 202 pounds. Height 6' 2". Leading pitcher of the International League, his first season in double "A" company. Won 17 games, lost 2. Won his first ten games. Met his first defeat at Buffalo July 13. Suffered his second setback September 3 at Baltimore. Coal miner in the winter months. Began with the Washington Club, Pennsylvania State Association in 1934. Since then Akron, Washington, Canton, Augusta, Newark. Was in 35 games, won 17 lost, pitched 174 innings allowed 162 hits, walked 100, fanned 77. Was in 10 complete games and pitched one shutout. Defeated in club in the loop at least once.

Joseph Beggs, pitcher. Born Aliquippa, Pa., November 4, 1914. Bats and throws right. Weight 180 pounds. Height 6' 2½". Was a member of the Newark "Wonder Team" in 1937. That season he won 21 games and lost 4. Went South with the New York Yankees this year. Returned to Newark late in July. In the playoffs Joe pitched fine ball and won twice. He also had the distinction of winning the first game against the Columbus Red Birds last year at Columbus, which eventually led to the Junior World Series Championship. Won the national collegiate javelin throwing championship while attending Geneva College. Pittsburgh Club gave him a trial in 1933. Since then pitched for Scranton Washington Pennsylvania State Association, Akron, Norfolk, Newark, New York Yankees, and Newark. His record this year: 12 games, won 6 lost 3, pitched 76 innings, allowed 85 hits, walked 15, struck out 44. Went the route 7 times and pitched one shut out.

Warren "Buddy" Rosar, catcher. Born Buffalo, N.Y., July 3, 1915. Bats and throws right. Weight 182 pounds. Height 5' 10½". Number one catcher of the Bears. Celebrated his second year in the league by hitting 387. Considered by many the leading hitter although

only in 91 games. Began in 1934 with Binghamton. Since then Wheeling, Norfolk, Binghamton, Newark. Was in 91 games, 323 at bats, scored 80 runs, made 125 hits, 25 doubles, 2 triples, 15 homers. Drove in 79 runs. Average 387.

Merril "Pinky" May, infielder. Born Laconia, Ind., January 18, 1912. Bats and throws right. Weight 175 pounds. Height 5' 10½". Began in 1932 with Cumberland. Since then Durham, Binghamton, Newark, Oakland, and Newark. Third leading hitter on the Bears. Considered by many the best third baseman in the league. Hit an even 400 in games played at night. Was in 146 games, 519 at bats, scored 97 runs, made 173 hits, 36 doubles, 5 triples, 12 homers. Drove in 107 runs. Batting average 333.

James "Goo-Gee" Gleeson, outfielder. Born Kansas City, Mo., March 5, 1913. Switch hitter. Throws right. Weight 195 pounds. Height 6' 1½". One of the 300 hitters of the Bears. His specialty is making two base hits. During the Season, socked 50 doubles, which broke the former record for a Newark player by one. The former mark was made in 1926 by George Burns. Last Season, as a member of the Newark "Wonder Team", he hit 47 two base wallops. Has been sold to the Chicago Cubs for 1939 delivery. Began in 1933 with Zanesville. Since then with New Orleans, Cleveland, and Newark. Was in 123 games, 484 at bats, scored 112 runs, made 151 hits, 50 doubles, 7 triples, and 16 home runs. Drove in 80 runs. Stole 8 bases. Batting average 312.

Francis Kelleher, outfielder. Born Crockett, Calif., August 22, 1917. Bats and throws right. Weight 188 pounds. Height 6' ¾". Graduate of St. Mary's College, Oakland. Was a member of the Newark Team in 1937. Began in 1936 with Akron. Since then, Newark, Kansas City, Oakland and Newark. Can play either the infield or outfield. Did a lot of pinch hitting during the past season. Was in 77 games, 273 at bats, scored 52 runs, made 77 hits, 12 doubles, one triple, 12 home runs. Drove in 60 runs. Batting average 282.

John H. Neun. Manager of the Newark Bears, a native of Baltimore, Maryland began playing ball with the Martinsburg Club of the Blue Ridge League in 1920. Made his debut in the big leagues as a member of the Detroit Tigers and while with that club in 1927 made an unassisted triple play in the ninth inning against the Cleveland Indians. While playing Neun was always a first baseman. After a trip back to the Baltimore club of the International League, Neun was sold to the Boston Nationals where he ended his major league career in 1931. He was purchased by Newark and helped the Bears to win the pennant and the Junior World Series in 1932. Johnny was appointed Manager of the Bears last November and repeated his flag winning performances by bringing the Bears home in front in the 1938 campaign of the International League.

Three

THE EAGLES PRIDE
1936–1948

During the 1930s and 1940s, Newark hosted two teams, one white and the other black. The Eagles of the Negro National League and the Bears of the all-white International League occupied the same city, even the same ballpark, Ruppert Stadium, but each represented a distinct racial group. The separate crowds that turned out to watch the Eagles and the Bears created their own unique, intimate space within the otherwise public world of professional sports. Separate teams reminded Newark fans of the deep racial divide that split the nation's pastime during segregation. Max Manning, a talented pitcher for the Eagles, remarked that "struggle" defined the lives of African American ballplayers both on and off the diamond. Second-class transportation and accommodations and lean paychecks constantly reminded black athletes that separate was anything but equal.

The relationship between race and professional baseball in Newark has a lengthy and sometimes painful history. In 1887, two African American ballplayers joined Newark's first professional baseball team, the Little Giants. Moses Fleetwood Walker and George Stovey both signed with Newark after starting their professional careers in Toledo and Jersey City, respectively. Historians regard Stovey as one of the best southpaws of all time and Walker as a reliable catcher with speed and defensive grace. Together in Newark, they formed baseball's first black battery. Walker and Stovey played without disturbance in Newark, until they experienced a hurtful racial incident that forever changed the game. On July 14, 1887, the National League's Chicago White Stockings (later the Cubs) visited Newark on an exhibition tour. The team's manager, Adrian (Cap) Anson, refused to allow his team to play if Stovey pitched. Newark deferred to Anson's racial intolerance and barred Stovey and Walker from the game. Later that same day, representatives from the International League met in the Genesee Hotel in Buffalo and voted to exclude blacks entirely from league play. Newark's color line had been drawn.

Black players and promoters responded by creating teams and leagues of their own. Regrettably, little is known of Newark's earliest black teams. The first one, the Newark Stars, disbanded in the middle of the 1926 season after winning only one game. Sol White, former player turned promoter and author of the first history of black baseball, managed the team in the Eastern Colored League. Pitcher Wayne Carr posted the team's only victory apparently behind the solid hitting of future Newark star Dick Seay. After a period of inactivity, the Newark Browns arrived in 1932. The Browns stayed in town for one year, playing in the East-West League under the direction of John Beckwith. The Newark Dodgers showed slightly more staying power by completing two full seasons, 1934 and 1935, in the Negro National League. The Dodgers had several outstanding players, including Ray Dandridge, who batted .408 in 1934, but still struggled through two losing seasons. Abe and Effa Manley, owners of the Brooklyn Eagles, purchased the Dodgers and merged both teams in 1936 as the Newark Eagles. The Manleys left Brooklyn's Ebbetts Field, moved the franchise to Newark, and contracted to play in Ruppert Stadium, home of the Newark Bears. The team provided Newark's black

community with a sense of pride and accomplishment. The Eagles won the Negro World Series in 1946 by defeating the powerful Kansas City Monarchs and ultimately sent five ballplayers—Larry Doby, Monte Irvin, Willie Wells, Ray Dandridge, and Leon Day—to the National Baseball Hall of Fame. Doby would later leave his mark on the game's history by becoming the first African American to play in the American League after Jackie Robinson shattered the color line in 1947 with the National League Brooklyn Dodgers.

While in Newark, blacks supported and identified with the Eagles just as the city's whites identified with the Bears. Black poet and playwright Amiri Baraka, who grew up watching the Eagles, wrote in his autobiography, "The Newark Eagles would have your heart there on the field, from what they was doing. From how they looked. But these were professional ballplayers. Legitimate black heroes. And we were intimate with them in a way and they were extensions of all of us, there, in a way that the Yankees and Dodgers [and Bears] and whatnot could never be."

The Eagles' departure from Newark in 1948 was a bittersweet experience. The Eagles, along with the entire Negro National League, faded out of existence after the successful integration of baseball. Effa Manley remarked, "Integration took place in '46 and I begged Abe in '47 to quit the next year because we dropped another $20,000. . . . The fans deserted us to go see the boys on the white teams." Effa, who fought her entire life for equal opportunity, had realized one dream but lost another.

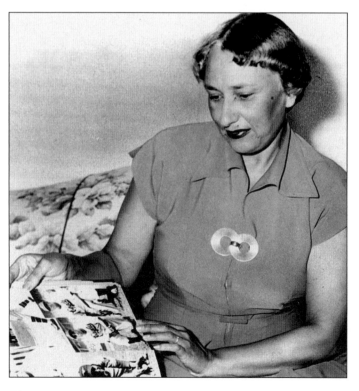

Effa Manley, co-owner and business manager of the Newark Eagles, proudly displays a scrapbook she collected during her years with the team. The book now resides at the National Baseball Hall of Fame in Cooperstown, New York. Additional records, including player contracts, correspondence, and financial statements, are part of the Newark Eagles manuscript collection housed in the Newark Public Library. These resources are the best collections of information on the Eagles and the Negro Leagues from 1936 to 1946. (Courtesy of Lawrence Hogan.)

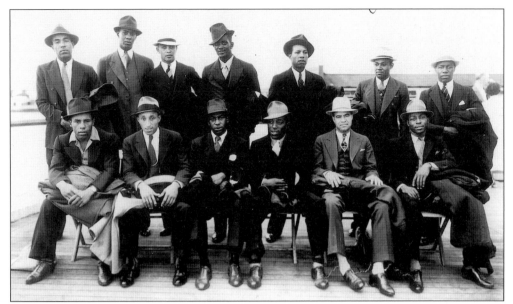

The Brooklyn Eagles, ready to embark on a winter league tour in Puerto Rico, merged with the Newark Dodgers to form the Newark Eagles in 1936. The Great Depression left both teams in financial trouble, but consolidation created one of the most successful and competitive teams in the Negro National League. (Courtesy of Lawrence Hogan.)

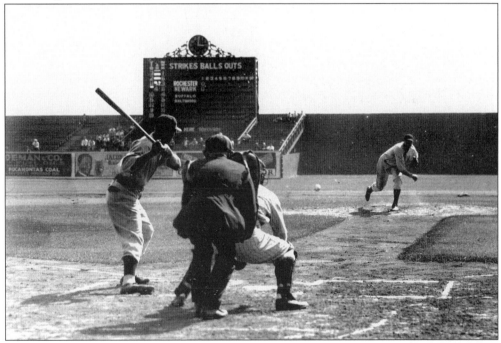

Upon their arrival in Newark, the Eagles contacted George Weiss, the vice president of the Newark Bears, and secured the right to lease Ruppert Stadium for all home games. Eagles financial records for 1939 reveal that the team agreed to pay the Bears 20 percent of the gross gate receipts for each game and established the following admission prices: 85¢ for box seats, 65¢ for grandstand, and 40¢ for bleachers. (Courtesy of the Newark Public Library.)

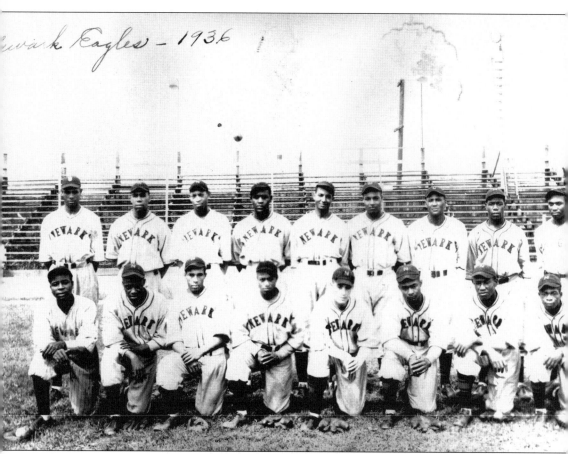

The 1936 Newark Eagles, under the guidance of manager William Bell, posted a 30-29 record, finishing in third place behind the Pittsburgh Crawfords and Philadelphia Stars. First baseman Mule Suttles nearly captured the coveted Fleet Walker Award by batting .365 and hitting 15 home runs. Josh Gibson, Pittsburgh's legendary home run hitter, received the honor. (Courtesy of the National Baseball Hall of Fame.)

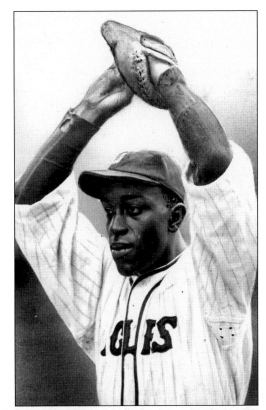

Leon Day made the switch from the Brooklyn Eagles to the Newark Dodgers in 1936. As a pitcher, Day regretted leaving Brooklyn's Ebbets Field for the confines of Newark's Ruppert Stadium, but he still managed to set the Negro League's single-season pitching record with a perfect 13-0 performance in 1937. (Courtesy of the Newark Public Library.)

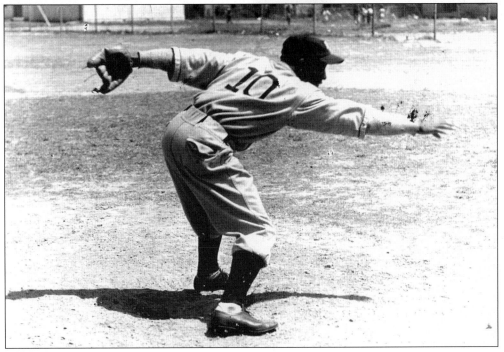

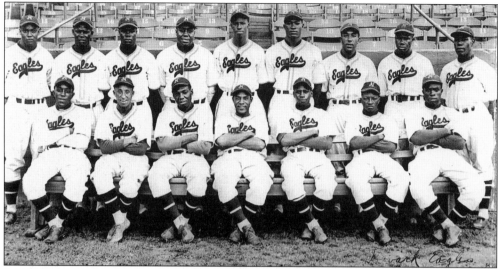

In 1939, the Eagles made their first appearance in the Negro National League playoffs. The team lost in the first round to the Baltimore Elite Giants, a team that featured a remarkable teenage catcher named Roy Campanella. (Courtesy of Lawrence Hogan.)

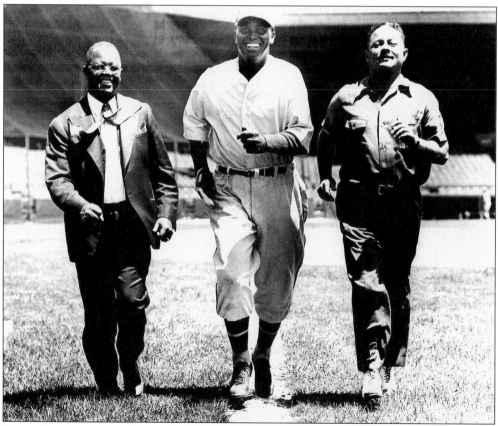

Pictured, from left to right, are Abe Manley (Eagles co-owner), Raleigh "Biz" Mackey (catcher and manager), and Bill White (Eagles general assistant). (Courtesy of Lawrence Hogan.)

Eagles first baseman Lennie Pearson was selected to play in five East-West All-Star Games during his outstanding 11-year career with the Eagles. A solid hitter, he batted .393 against the Kansas City Monarchs in the 1946 Negro World Series. Between 1937 and 1948, the Eagles relied on his consistent batting, smooth defensive glove, and good speed. Pearson grew up close to Newark in East Orange, where he attended high school with future teammate Monte Irvin. He remained in Newark as a tavern owner after the end of his baseball career. (Courtesy of the Newark Public Library.)

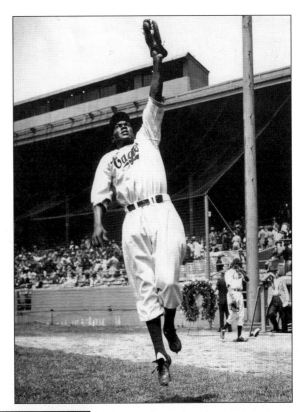

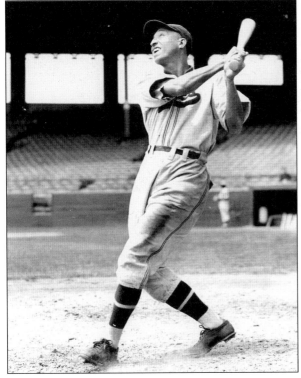

The player who epitomized black baseball in Newark was Dick Seay. He began his long career in Newark playing for the Stars in 1926, then joining the Browns in 1931, and ending with the Eagles between 1937 and 1940. Baseball analysts consider Seay the best defensive second baseman in the Negro National League. In 1937, he anchored the Eagles' "Million Dollar Infield" with his superior fielding, strong arm, and ability to turn the double play. (Courtesy of the Newark Public Library.)

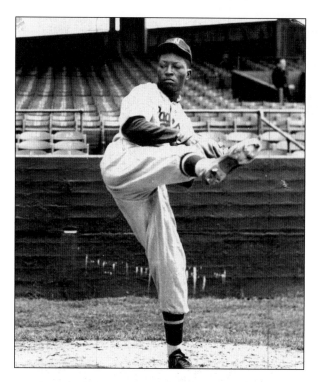

Southpaw Jimmy "Mr. Five-by-Five" Hill warms up in Ruppert Stadium before a game with the New York Cubans. The short and stocky Hill was discovered while pitching batting practice for the major-league Detroit Tigers during spring training in Florida. In 1941, he was selected to play in the East-West All-Star Game, where he pitched hitless ball as a reliever. (Courtesy of the Newark Public Library.)

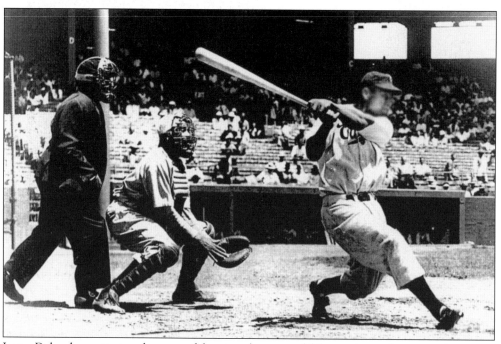

Larry Doby demonstrates the powerful swing that earned him a trip to the major leagues in 1947. Doby debuted with the Cleveland Indians as the first black player in the American League. (Courtesy of Lawrence Hogan.)

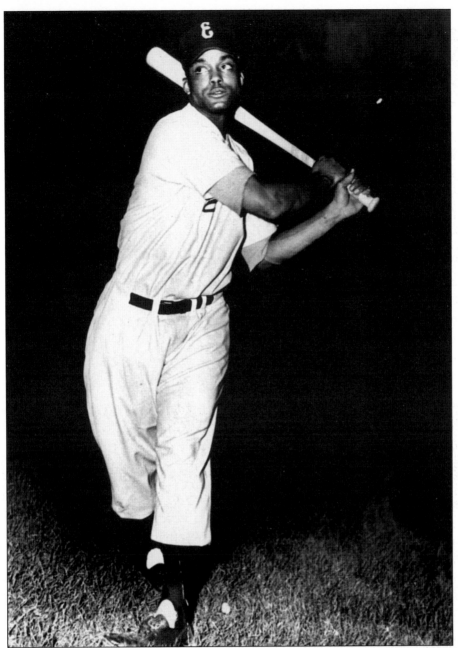

Monte Irvin, who later became a star player for the New York Giants and member of the Baseball Hall of Fame, signed with the Eagles in 1937 and remained in Newark until 1948. He excelled at three positions: outfield, shortstop, and third base. Irvin lived in New Jersey as a youngster and played ball for one of the state's outstanding semiprofessional teams, the Orange Triangles. Like so many others, Irvin's career was interrupted by military service during World War II. While on active duty in France, Irvin wrote to Eagles owner Effa Manley that he "ran into 'Big Six' Riddick who use to play short stop for us and even though I didn't see him, Max Manning was in the same city as I was, he was fine but homesick like the rest of us." (Courtesy of Lawrence Hogan.)

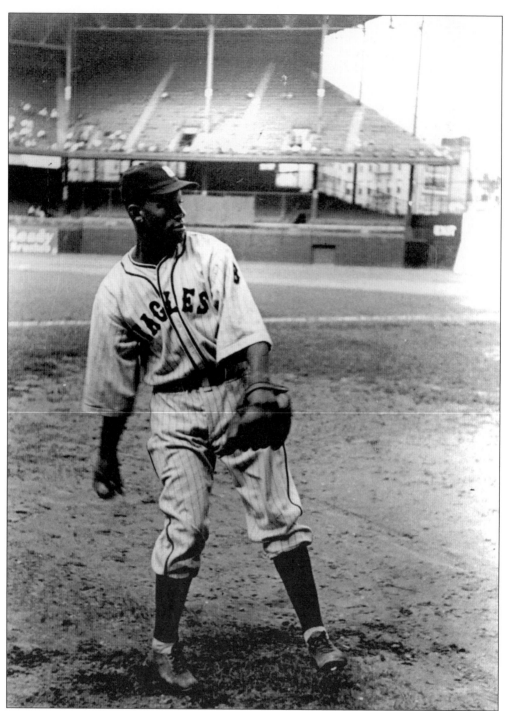

Newark fans and fellow Eagle teammates considered Dick "the King" Lundy a member of baseball's royalty based upon his natural leadership ability, dignity, and sportsmanship. Lundy played shortstop for the Eagles during the twilight of his career between 1936 and 1938. In Newark, Lundy accepted the role of trusted teacher and instructed Willie Wells and Ray Dandridge on the finer aspects of fielding. (Courtesy of Lawrence Hogan.)

Everett Marcelle served as a journeyman catcher for the Eagles in 1948. He was the son of Oliver Marcelle, an All-Star in the early black leagues of the 1920s and early 1930s. According to baseball writer James A. Riley, Everett asked Biz Mackey, then serving as manager of the Baltimore Elite Giants, for a tryout as a catcher. Mackey suggested that Marcelle observe a youngster on his team—Roy Campanella. After watching Campanella make several outstanding plays, Marcelle reportedly informed Mackey that he could play other positions too. (Courtesy of the Newark Public Library.)

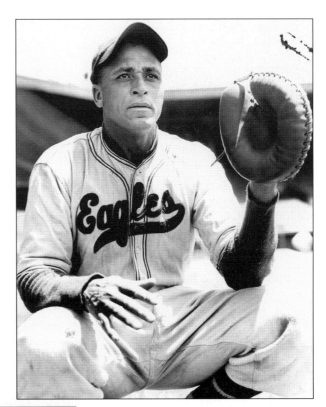

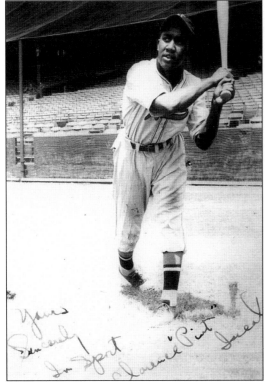

Clarence "Pint" Israel was popular among fans for his hustle and smooth glove. He replaced an injured Pat Paterson at third base during the Negro World Series in 1946 and delivered clutch hitting to help the Eagles clinch the title. (Courtesy of Lawrence Hogan.)

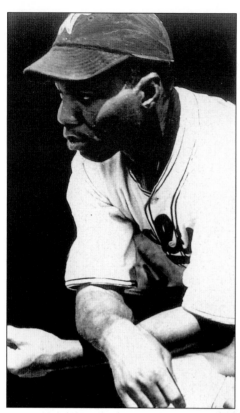

John Holway, author of several histories on black baseball, contends that most old-timers consider Willie Wells the finest black shortstop in baseball. Eagles owner Effa Manley added "the finest shortstop, black or white." Wells piloted the team to its only championship in 1946. (Courtesy of Lawrence Hogan.)

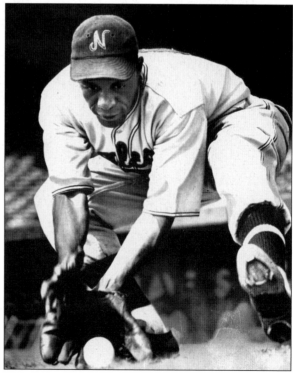

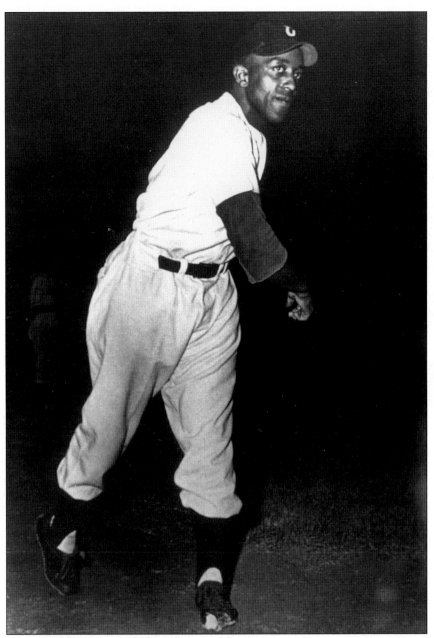

The Eagles publicity department requested information on all players. Leon Day's handwritten response, located in the Eagles manuscript collection, recorded the following: "Permanent Address: 2411 Puget St., Baltimore Maryland; Date of Birth: 1916; Weight: 175; Height 5'9"; Schools Attended: Merrell Back, Harvey Johnson Junior High, and Douglas Senior High; First Learned to Play Where: Baltimore; Teams Played With: Mt. Winans A.C., Silver Moons, Baltimore Black Sox, Brooklyn Eagles, and Newark Eagles; Positions Played: second base, outfield, pitcher; Hobbies: pool and stamp collecting; Occupation During the Winter: Baseball; Batting Average: .295; Fielding Average .995; Championship Teams: Brooklyn eagles in Puerto Rico Winter League in 1935; Married or Single: Single; Bat: right; Throw: Right." (Courtesy of Lawrence Hogan.)

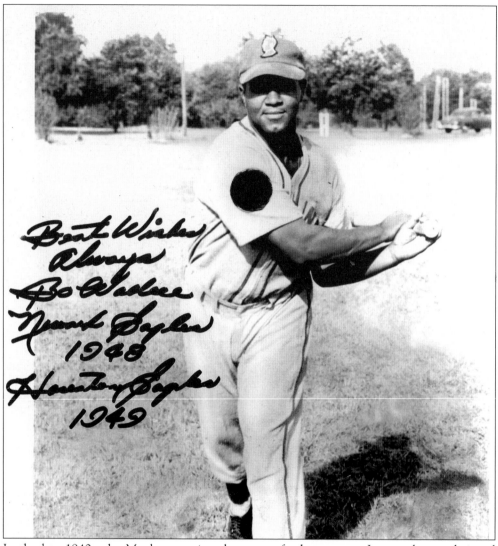

In the late 1940s, the Manleys continued to scout for homegrown Jersey talent and signed pitcher Don Newcombe from Madison in 1944 and catcher Bo Wallace, pictured here, from Elizabeth in 1948.

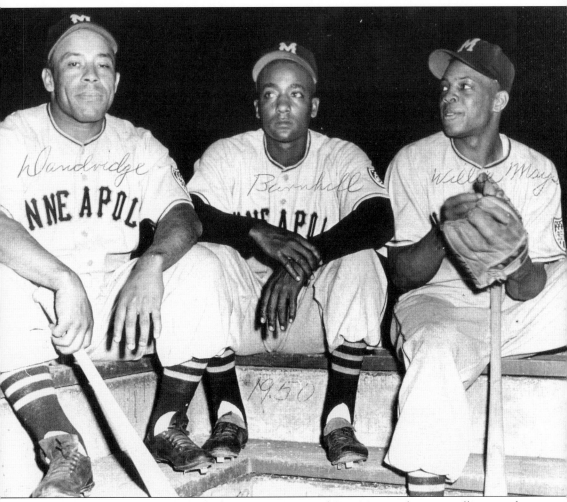

While Eagle players such as Larry Doby, Monte Irvin, and Don Newcombe eventually entered the major leagues, Ray Dandridge ended his career in the minors with the Giants' Triple-A farm club, the Minneapolis Millers. The Giants refused to promote or trade Dandridge. He is pictured with fellow teammates pitcher Dave Barnhill and all-time great center fielder Willie Mays. (Courtesy of the Newark Public Library.)

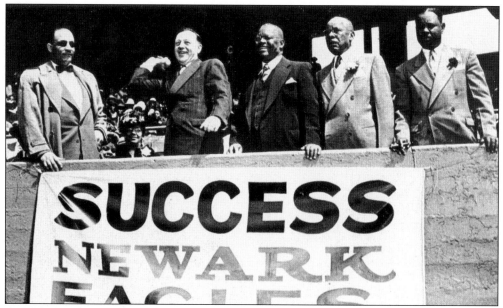

According to baseball historian James Overmyer, the relationship between the Eagles and the city was best demonstrated on opening day. White politicians, including Mayor Vincent T. Murphy (seen here throwing out the first ball), regularly attended the festivities to attract black support. The day's events were, however, organized by blacks for blacks, and featured bands, a military color guard, and honored guests notable for their work in achieving racial equality. (Courtesy of the Newark Public Library.)

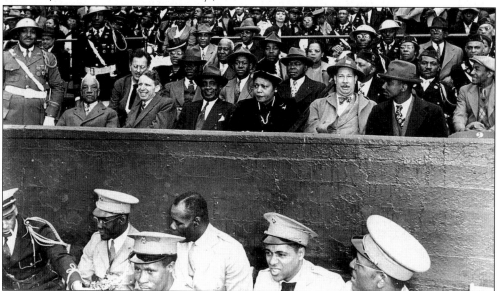

Effa and Abe Manley personally invited several military and political dignitaries to help celebrate opening day in 1946. Seen here are Capt. J. Mercer Burrell; L. Dewey Brown, commander of American Legion Post 152; Henry Jackson; Harold J. Adonis; Alfred E. Driscoll, aspirant for governor; Prosper Brewer, Third Ward Republican leader; Assemblyman J. Otte Hill and his wife; E.A. Willis; Melvin Johnson; J. Franklin King; and James Snead. (Courtesy of Lawrence Hogan.)

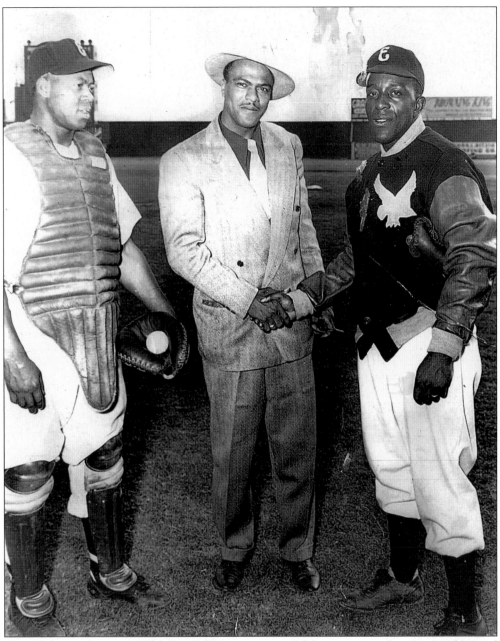

Newark boasted one of black baseball's most successful batteries, catcher Biz Mackey and pitcher Leon Day. Day holds the single-season strikeout record in both the Negro National League and the Puerto Rican League. (Courtesy of Lawrence Hogan.)

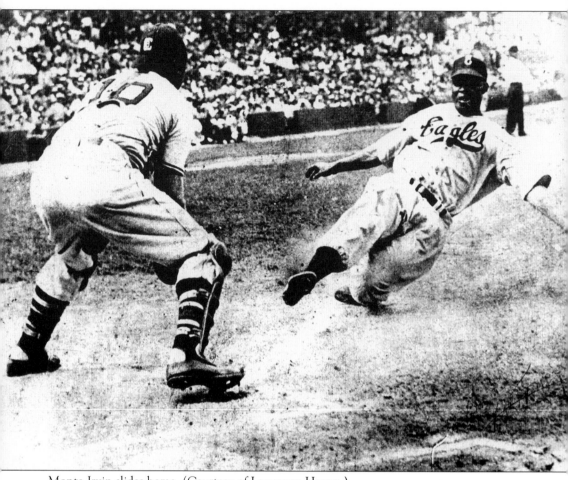

Monte Irvin slides home. (Courtesy of Lawrence Hogan.)

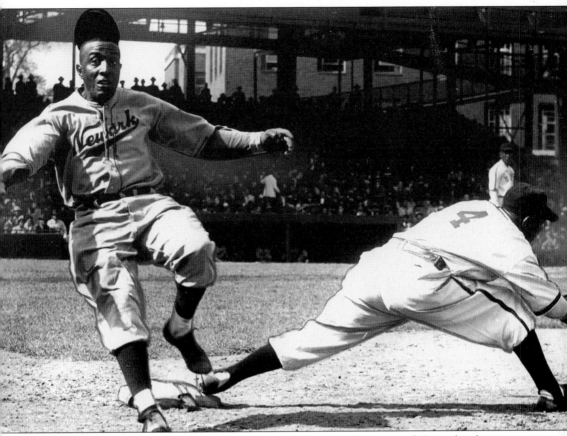

Leon Day beats out a base hit despite the outstretched arms of Homestead Grays first baseman Buck Leonard. Day was certainly the most versatile player in Negro League history. He was the ace on the Eagles pitching staff, but his extraordinary fielding, batting, and speed kept him in the lineup on a regular basis. During his career, he played every position except catcher. (Courtesy of Lawrence Hogan.)

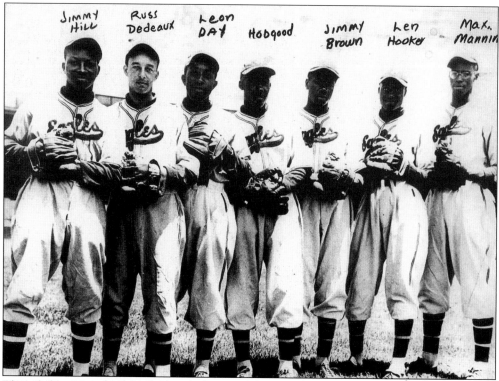

The reliable strength of the Eagles pitching staff kept the team competitive throughout most of the 1940s. Pictured, from left to right, are Jimmy Hill, Russ Dedeaux, Leon Day, Freddie Hobgood, Jimmy Brown, Len Hooker, and Max Manning. (Courtesy of Lawrence Hogan.)

In this rare clubhouse photograph, Ray Dandridge and teammates prepare before a game. Eagles players considered Dandridge the clubhouse leader for his humor, leadership, and spirited play. (Courtesy of Lawrence Hogan.)

The Eagles traveled across the Hudson River to play the New York Cuban Stars at the Polo Grounds and the New York Black Yankees at Yankee Stadium. The Cubans, owned by Alex Pompey, contained mostly black ballplayers despite the name. (Courtesy of Lawrence Hogan.)

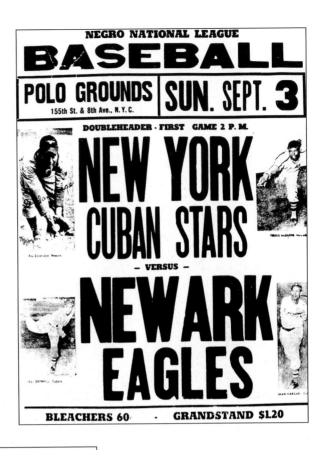

NEGRO NATIONAL LEAGUE

BASEBALL

POLO GROUNDS | **SUN. SEPT. 3**
155th St. & 8th Ave., N.Y.C.

DOUBLEHEADER · FIRST GAME 2 P. M.

NEW YORK
CUBAN STARS

— VERSUS —

NEWARK
EAGLES

BLEACHERS 60 · **GRANDSTAND $1.20**

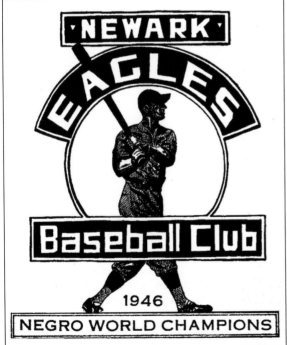

·NEWARK·
EAGLES
Baseball Club
1946
NEGRO WORLD CHAMPIONS

All Eagles correspondence and letterhead carried this logo after the team's 1946 championship season. Local businessmen displayed this symbol proudly in store windows. (Courtesy of Lawrence Hogan.)

83

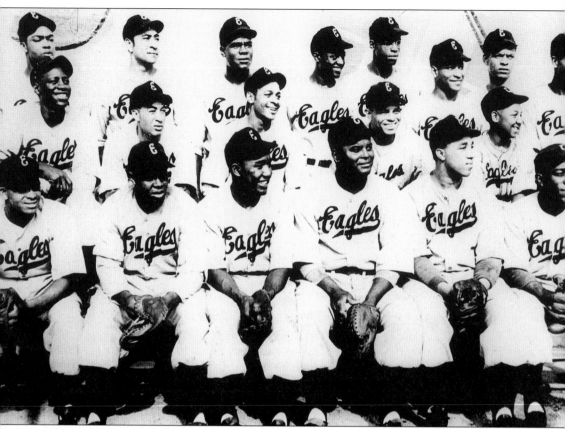

"Boy did we have a ball club in 1946," exclaimed Effa Manley. The 1946 Eagles World Series championship team is shown here. From left to right are the following: (front row) ? Selton, Charles Parks, Clarence Israel, Raleigh Mackey, Bob Harvey, and Leon Day; (middle row) Leon Ruffin, Warren Peace, Jim Wilkes, and Bobby Williams; (back row) Monte Irvin, Johnny Davis, Lennie Pearson, Len Hooker, Max Manning, Cecil Cole, Rufus Lewis, and Larry Doby. (Courtesy of Lawrence Hogan.)

Larry Doby slides home safely during the Eagles opener in 1946. According to a report in the *New Jersey Afro-American*, catcher Bill Cash of the Philadelphia Stars protested the call, confronted the home plate umpire, and knocked him to the ground. The incident remains own of the most controversial events in Negro League history. (Courtesy of Lawrence Hogan.)

Stars manager Homer Curry also threatened the umpire, but several policemen escorted him from the field. Curry blamed his behavior on the excitement of the game and later apologized for himself and Cash. (Courtesy of Lawrence Hogan.)

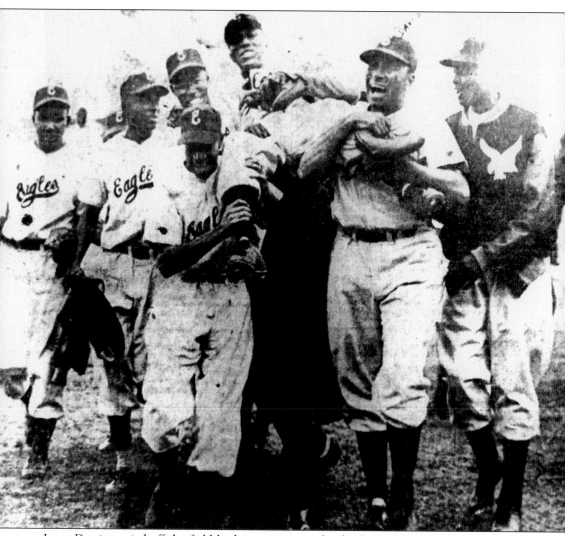

Leon Day is carried off the field by his teammates after hurling a no-hitter to start the 1946 season. Day celebrated his return to the Eagles after three years in the army by pitching a no-hit, no-run game against the Philadelphia Stars, 2-0, before a crowd of 8,514 fans. Clarence Israel, Larry Doby, and Jim Davis collected two hits apiece in the victory. (Courtesy of Lawrence Hogan.)

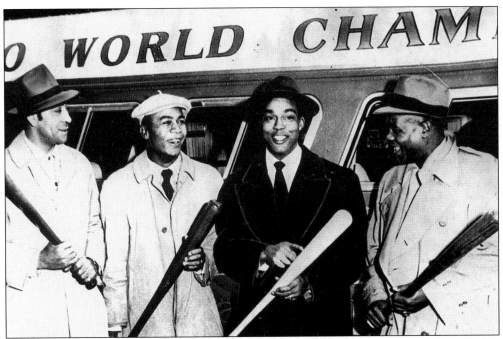

Four of the Eagles' heavy hitters stand in front of the team's bus before it leaves for spring training in Jacksonville, Florida, in 1947. From left to right are Johnnie Davis, Larry Doby, Monte Irvin, and Lennie Pearson. (Courtesy of Lawrence Hogan.)

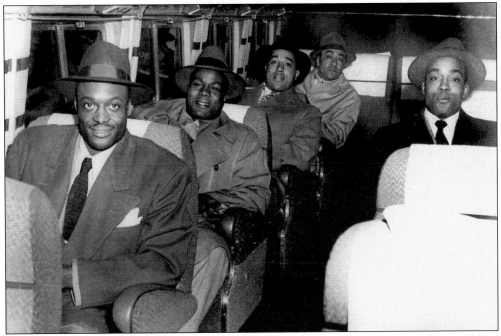

Pitcher Max Manning recalled, "The memories that come to my mind in terms of the friendships and the fun we used to have, the traveling and the buses, telling jokes, singing, and doing all those different kinds of things in the bus, the ribbing and the funny things that we did—they're memories that can never be erased from my mind." (Courtesy of Lawrence Hogan.)

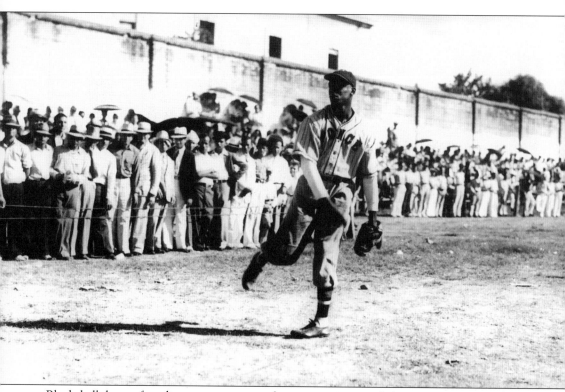

Black ballplayers found temporary escape from segregation and discrimination in Cuba and Latin America. Many Eagles players traveled to Mexico, Venezuela, Puerto Rico, and Cuba during the off-season to supplement their income and stay in shape. Max "Dr. Cyclops" Manning pitched for the Ponce team in Puerto Rico in 1938 and later became a national hero in Cuba as a member of the Cienfuegos. (Courtesy of Lawrence Hogan.)

Ray Dandridge spent more time in Latin America than any other Eagles ballplayer did. Dandridge played the regular seasons of 1940–1943 in Mexico, much to the dismay of Eagles owner Abe Manley. In a rare photograph, probably taken in 1940, Dandridge (right) stands next to slugger and fellow Veracruz teammate Josh Gibson. (Courtesy of Lawrence Hogan.)

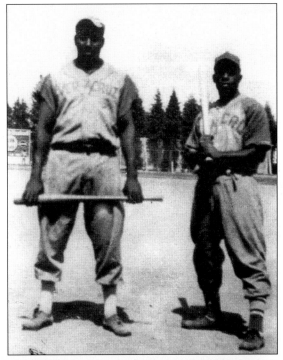

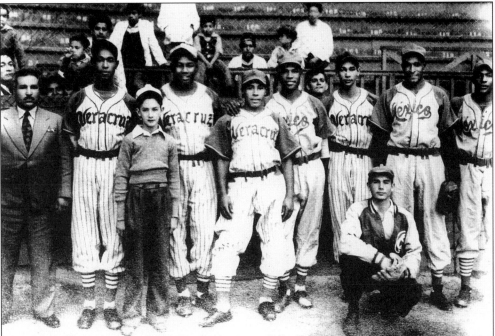

Dandridge stands with Veracruz teammates. The players include Barney Brown, Josh Gibson, Dandridge, Leroy Matlock, Johnny Taylor, and "Wild Bill" Wright. Veracruz, owned by Mexican millionaire and baseball promoter Jorge Pasquel, dominated the Mexican League in the 1940s. Dandridge was later inducted into the Mexican Hall of Fame for his outstanding play. (Courtesy of Lawrence Hogan.)

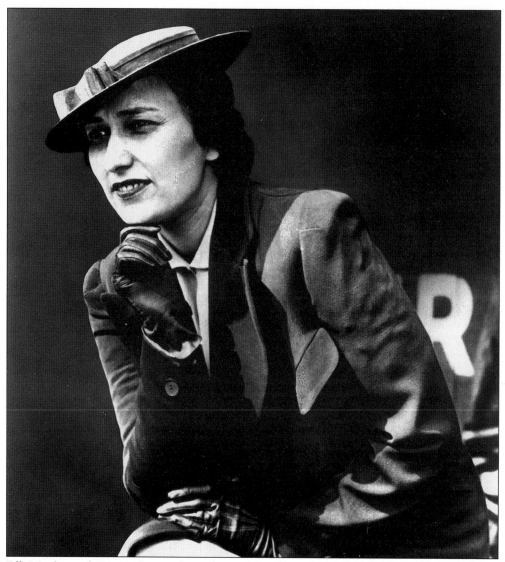

Effa Manley, a champion for racial equality and freedom, played a critical role in advancing the modern civil-rights movement. In 1941, she worked with the March on Washington Committee to persuade Pres. Franklin Delano Roosevelt to eliminate racial discrimination in the nation's defense industry. She proved a tireless worker for the National Association for the Advancement of Colored People (NAACP), the premier civil-rights organization in the 1940s. (Courtesy of Lawrence Hogan.)

NATIONAL ASSOCIATION FOR THE ADVANCEMENT OF COLORED PEOPLE

20 WEST 40TH STREET, NEW YORK 18, N. Y.

LOngacre 3-6890

Official Organ: The Crisis

April 5, 1946

Mrs. Effa Manley
71 Crawford Street
Newark, New Jersey

Dear Mrs. Manley:

Confirming our telephone conversation of two days ago, I want to sincerely thank you for your interest in our work and your generous offer to let us take up funds on the opening day of the Negro League.

When the matter is definite would you be able to let us have plans of the Ruppert stadium and the Yankee stadium so that we could have the facts in front of us and be able to allocate the number of girls to be used for each section. I think you will agree that this is important, since every section should be covered adequately. We can get the containers.

I hope you will let me hear from you just as soon as possible. Again, please accept our sincere thanks for your aid and cooperation.

Sincerely yours,

Madison S. Jones, Jr.,
Administrative Assistant

MSJ:dp

Frank Jones
272 N N 4 St
Ed 4-3537

122 N/38
Au 3-2743

Effa Manley coordinated ballpark activities with the NAACP to promote and finance the work of the organization. In the late 1940s, the NAACP initiated challenges to school segregation that eventually resulted in the historic *Brown v. Board of Education* decision to integrate the nation's public schools.

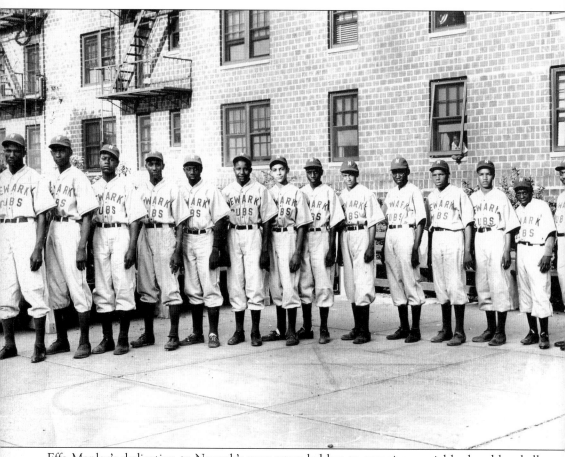

Effa Manley's dedication to Newark's youngsters led her to organize a neighborhood baseball team called the Cubs. Manley provided the team's uniforms under the condition that players "keep care of the suit, wash it when it gets dirty, or when the coach tells me to." More importantly, students had to maintain good grades and "try to set a high standard for boys my age" to qualify as Cub members. (Courtesy of the Newark Public Library.)

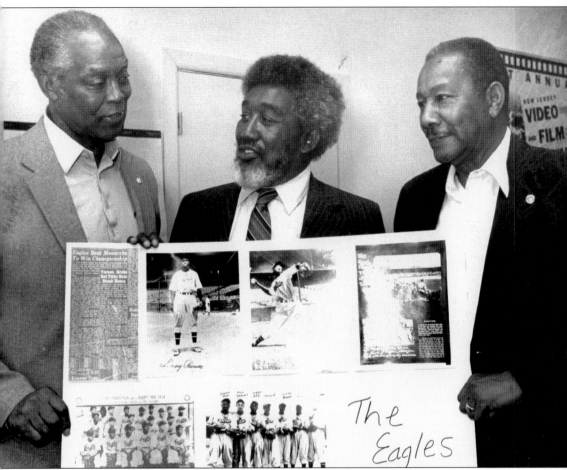

Monte Irvin (left), Clarence Israel (center), and Sy Morton are shown at the premiere of *Before You Can Say Jackie Robinson*, a documentary on black baseball. The film was produced and directed by Lawrence Hogan and Thomas Guy. (Courtesy of the Newark Public Library.)

Old friends Monte Irvin (left) and Ray Dandridge reminisce at the opening of Dick Seay Memorial Field in Jersey City in 1988. (Courtesy of Newark Public Library.)

Ray Dandridge celebrates with Little Leaguers at the opening of Ray Dandridge Field at West Side Park in Newark. (Courtesy of Lawrence Hogan.)

The 1945 Newark Eagles

Standings

First Half

Team	W	L	Pct.
Homestead Grays	18	7	.720
Philadelphia Stars	14	9	.609
Baltimore Elite Giants	13	9	.591
Newark Eagles	11	9	.550
New York Cubans	3	11	.214
New York Black Yankees	2	16	.111

Second Half

Team	W	L	Pct.
Homestead Grays	14	6	.700
Baltimore Elite Giants	12	8	.600
Newark Eagles	10	8	.556
Philadelphia Stars	7	10	.412
New York Black Yankees	5	10	.333
New York Cubans	3	9	.250

Player Profiles

In 1945 and 1946, J.L. Kessler served as the publicist for the Eagles. He provided biographical sketches of the Newark players to local sportswriters and to the media in sites supporting teams in the Negro National League. This peppery report was filed just after the start of the 1945 season:

Despite the loss of an even dozen men to the armed forces, and another to the Mexican League, the Newark Eagles will be right there when the final curtain is draped on the NNL champions this season's end. The rookies and the vets [who] will make up the team are batting sharply and fielding brilliantly. Here is a pin-point sketch of the players and the probable batting order.

Fran Matthews, No. 27-OF. A speed merchant, totes a big bat, and is one of the classiest fielders in the league. No newcomer and he knows his way around.

Murray Watkins, No. 29-3B. Watkins is a pint-sized individual with plenty of nerve. He is batting over 300 and gets in front of sizzlers that the average player would wave at and let go as a base hit. Has a steel arm that allows him to throw out speedsters after knocking the ball down. Plans to make the East-West game, if played this year, and is well on his way.

Willie Wells, No. 20-SS. One of the greatest shortstops of all time, is Willie, who for the last three years has been pounding the ball like mad. He gets balls that the youngsters don't get near because of his uncanny sense of knowing where to go at the crack of the bat. The manager of the Eagles this year and vows to finish on or near the "heap of money position."

Lenny Pearson, No. 22-1B. A Natural all around athlete who would be in the majors if—. Hitting in the neighborhood of 400 and scooping up any ball in sight. One of the few holdovers from last year.

Robert Harvey, No. 21-OF. Bob is the big gun in the Eagles' attack and hits hard to any field. A hot weather player and will be traffic when that sets in.

John Davis, No. 31-OF. Johnny is a fence buster and has been banging them to the far corner, but some of his longest "wappos" have been long outs. He still sports a 300 batting average, and when they start falling where they ain't, watch out for Davis!

Raleigh Mackey, No. 40-C. The silver-thatched "Biz" has been lured from his rocking chair out in sunny California. To show you the affect of the climate on his throwing arm, Mackey has cut down five men in one day trying to steal. He was aided by the fancy tagging of Wells, the best in the business. Batting a cool 300.

Lloyd Banks, No. 35-2B. Banks is a big strong rookie who blends with veteran Wells on double plays. He becomes smoother every day around the keystone sack.

Terris McDuffie, No. 26-P. Terris "The Great" had a trial with the Brooklyn Dodgers who praised him highly. Terris had a field day in the Eagles' opener, handling five chances without a slip, shutting out the [New York] Cubans and pinning two fast ones for homers! A potential twenty game winner.

Jimmy Hill, No. 32-P. This diminutive southpaw of 140 lbs. has been tossing his slants in such a fashion as to make his fans believe that he will be up to four years ago. He was a sensation.

Donald Newcombe, No. 23-P. Don is definitely the no. 3 man on the staff. He has speed, change of pace and strength. Don is 6' 3" and weighs 220.

Willie Wynn, No 11-C. Steady young catcher who will be of much use as an understudy for Mackey. A hard hitter and a hickory arm are his assets.

Four

THE BEARS RETURN
1999–PRESENT

On July 16, 1999, professional baseball resurfaced in Newark after a 50-year absence. The city's legendary Bears had returned home, and the celebration surrounding their arrival sparked historical interest in the team and its past. On opening night, sportswriter Jerry Izenberg remarked that after five long decades, the mythical "No Game Today" sign was finally removed as baseball made its comeback to "the baseball town." In particular, the Bears' homecoming stirred the individual and collective memory of those who lived in Newark during the 1930s and 1940s, when baseball resided at the "core of its very fiber."

The rebirth of the Bears connected the city's baseball past to the present. The franchise adopted the name of its minor-league predecessor but dedicated its ballpark as Bears and Eagles Riverfront Stadium to remember Newark's presence in the Negro National League. According to Rick Cerone, the team's founder and co-owner, the current Bears honor the "tremendous contributions the city of Newark has made to professional baseball." Cerone, a former New York Yankee catcher who grew up in Newark, understood the importance of baseball to the city and worked closely with local political officials to reestablish the sport. Recently, New Jersey businessman Steve Kalafer, whose father served as a bat boy for the Bears in the 1930s, joined Cerone as co-owner.

As a member of the Atlantic League of Professional Baseball, the Bears are no longer affiliated with the Yankees, or any major-league ball club. Instead, the team consists of young players and experienced big-league veterans working hard to prove they belong in the majors. Newark, a city of opportunity, can understand and support a team like that.

The return of the Bears to Newark on July 16, 1999, featured honored guests from Newark's legendary baseball past. Yogi Berra, who played for the Bears in 1946, reminisced with Bo Wallace, a fellow catcher, who played for the Eagles in 1948, and Jim Carter, who pitched for the Eagles in 1948. Segregation kept Newark's black and white teams from competing against each other in the 1940s, but the common language of baseball resulted in this poignant moment between old backstops. (Photograph by Bill Lenahan.)

Rick Cerone, Bears founder and co-owner, oversees construction of Riverfront Stadium. Cerone grew up in Newark, achieved All-American honors at nearby Seton Hall University, and enjoyed a successful major-league career as a catcher, mostly with the New York Yankees. Cerone deserves most of the credit for bringing professional baseball back to the city. (Courtesy of the Newark Public Library.)

The team's current home, Bears and Eagles Riverfront Stadium, commemorates the memory of Newark's cherished teams of the 1930s and 1940s. (Photograph by Colin Burke.)

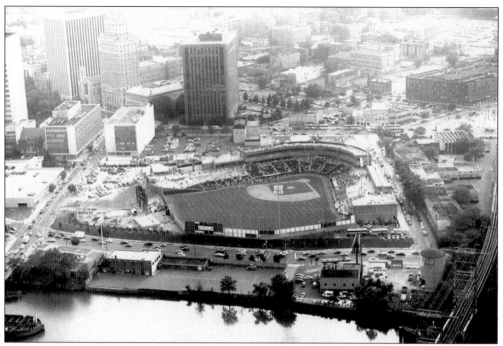

Newark's hometown paper, the *Star Ledger*, described the stadium as "decidedly urban, with the Stickle Bridge looming over left field, and the occasional sight of a New Jersey Transit train pulling into or out of Broad Street Station. During a pitching change, turn around and get a good look at Newark's skyline." (Courtesy of the Newark Bears.)

Yogi Berra officially welcomes the Bears back home by throwing out the first pitch in the team's inaugural game. (Courtesy of the Newark Bears.)

Berra's opening pitch nearly hit teammate and Yankee great Phil Rizzuto. Rick Cerone accepted catching responsibilities for the event. (Photograph by Bill Lenahan.)

Berra, Rizutto, and Cerone helped renew the Yankee presence in Newark and linked the Bears of yesteryear with the present team. (Photograph by Bill Lenahan.)

Bears first baseman Doug Jennings hit a walk-off homer in the bottom of the 10th inning to give Newark a dramatic win in its first game in Newark. (Photograph by Kyle Burke.)

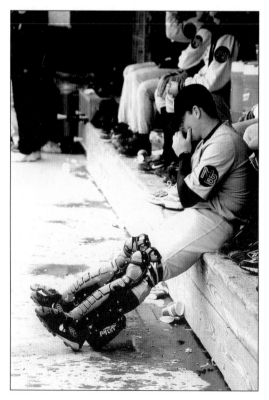

Bears players did not always enjoy the comfort of their own dugout. In 1998, the team awaited construction of Riverfront Stadium and played all of its games on the road with a few designated home games in Bridgeport, Connecticut. (Photograph by Gordon Forsyth.)

Bears pitcher Tim Cain (left) joins teammates during spring training in Homestead, Florida. Cain was a member of the Bears' inaugural team in 1998 and remains Newark's career leader in wins, games started, complete games, strikeouts, and innings pitched. (Courtesy of the Newark Bears.)

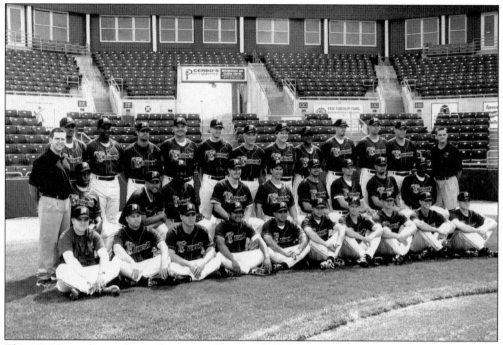

The 1999 Bears featured a combination of veteran ballplayers and youngsters. Both groups hoped to attract the attention of major-league clubs. Under the direction of manager Tom O'Malley, the team finished in fourth place with a 55-64 record. (Photograph by Colin Burke.)

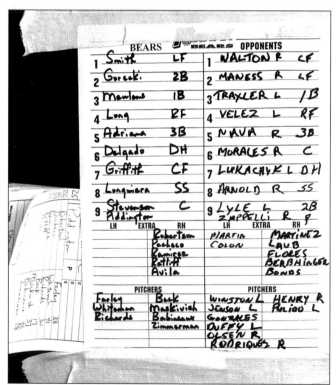

Shown is the 1999 starting lineup. (Photograph by Colin Burke.)

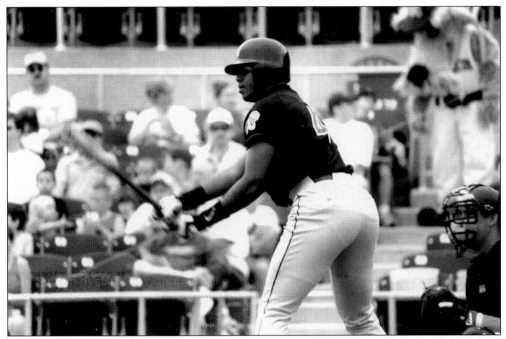

Former New York Yankee prospect Hensley "Bam Bam" Muelens played third base for the 1999 team. (Photograph by Kyle Burke.)

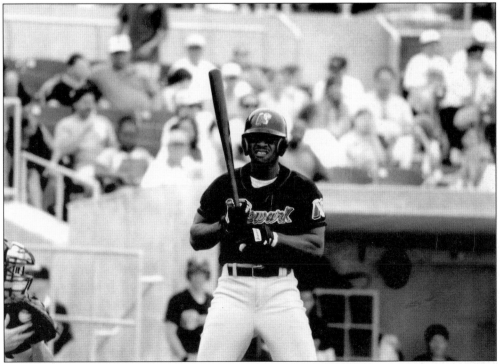

Young outfielder Sharnol Adriana batted .334 in 1999, placing him second on the Bears' single-season batting list. (Photograph by Kyle Burke.)

Bobby Hill, the All-American shortstop from the University of Miami and first-round draft pick of the Chicago White Sox in 2000, experienced signing difficulties with Chicago and opted to sign with the Bears. In Newark, Hill explained, "I was able to get some valuable experience playing against older guys at a level I consider to be comparable to Triple- or Double-A. I got my feet wet in professional ball earlier and found out what to expect in professional baseball. Players and former major-leaguers on the team, Ozzie Canseco and Craig Worthington, gave me a lot of tips and helped me learn a lot." Hill stands between hitting coach Tony Ferrara (left) and manager Tom O'Malley at a press conference to announce his signing. Seen below are, from left to right, Ozzie Canseco, Tony Ferrara, and Bobby Hill. (Courtesy of the Newark Bears.)

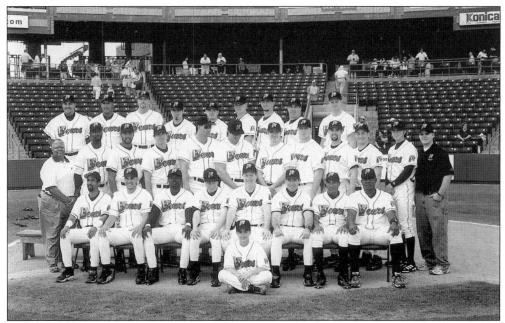

The 2001 team included several well-known baseball stars. According to *Baseball America*, the signings of major-leaguers Jose Canseco, Jaime Navarro, Jack Armstrong, Lance Johnson, and Jim Leyritz, and the later addition of Pete Incaviglia, made the team the top story in independent baseball. (Photograph by Colin Burke.)

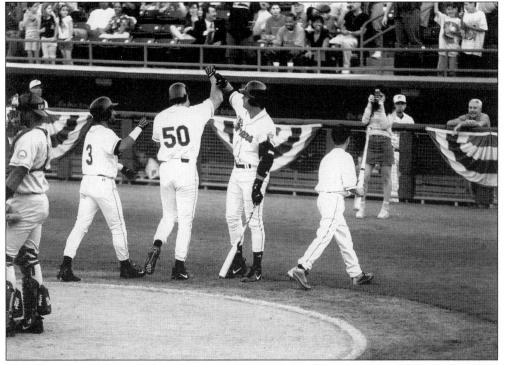

Jose Canseco and Lance Johnson congratulate Jose's brother Ozzie after hitting a three-run homer. (Photograph by Colin Burke.)

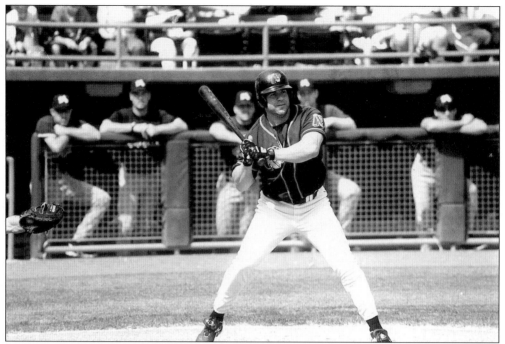

Pete Incaviglia, who spent 15 years in the major leagues, signed with the Bears in July 2001. He had prior experience in the Atlantic League as a member of the Nashua Pride. (Photograph by Kyle Burke.)

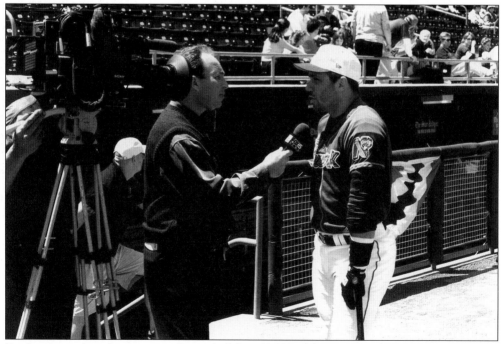

Jim Leyritz—whose home run in Game 4 of the 1996 World Series was the turning point in the Yankees' triumph over the Atlanta Braves—joined the Bears at the start of the 2001 season but finished the year as a member of the San Diego Padres. (Photograph by Colin Burke.)

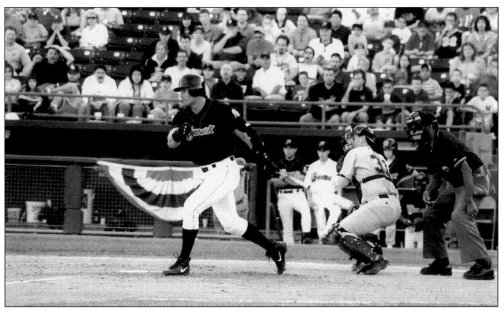

Jose Canseco spent just enough time in Newark to thrill fans with his powerful home run swing. Canseco started in left field for the Bears in 2001, but by midseason, the Chicago White Sox had acquired his services. (Photograph by Gordon Forsyth.)

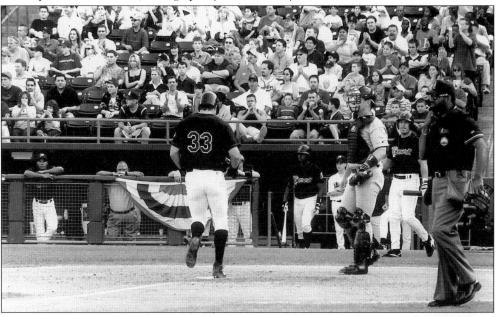

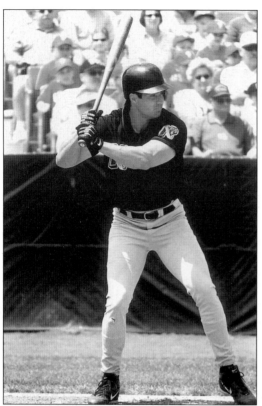

Bears fans regarded Ozzie Canseco, Jose's brother, as one of their hometown heroes during the 2000 and 2001 seasons. He still holds the Atlantic League single-season home run record with 48. (Photograph by Gordon Forsyth.)

Ozzie captured the Atlantic League's MVP award for 2000. (Photograph by Colin Burke.)

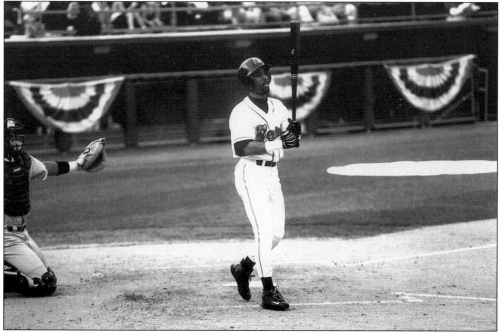

In his attempt at a big-league comeback, Lance Johnson provided superior leadoff hitting and speed for the Bears. Johnson batted .291 and stole 327 bases during his career, mostly with the Chicago White Sox. (Photograph by Colin Burke.)

Newark hosted the 2001 Atlantic League All-Star Game. Four Bears started the contest, including catcher Peto Ramirez (pictured here), second baseman Steve Hine, and outfielders Joe Maths and Ric Johnson. Newark also supplied three pitchers: Jaime Navarro, Jack Armstrong, and Frank Thompson. Infielder Jose Alguacil made the team as a reserve infielder. (Courtesy of the Newark Bears.)

Joe Borowski anchored the Bears bullpen in 2000. (Courtesy of the Newark Bears.)

David Moraga provided consistent pitching during the 2002 season. (Photograph by Kyle Burke.)

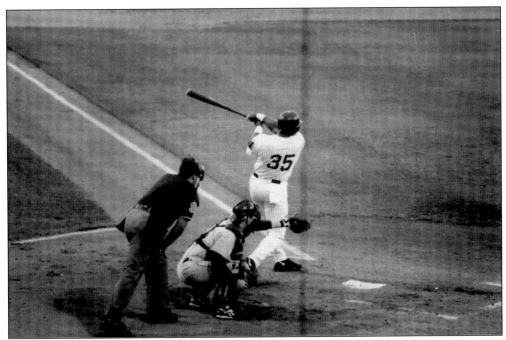

Outfielder Jimmy Hurst became the first player in Atlantic League history to capture the coveted Triple Crown Championship. Hurst completed the 2002 season with a .341 batting average, 35 home runs, and 101 runs batted in. (Photograph by Kyle Burke.)

Wes Chamberlin, former player for the Phillies and the Red Sox, was named Atlantic League Player of the Month for May 2002. (Courtesy of the Newark Bears.)

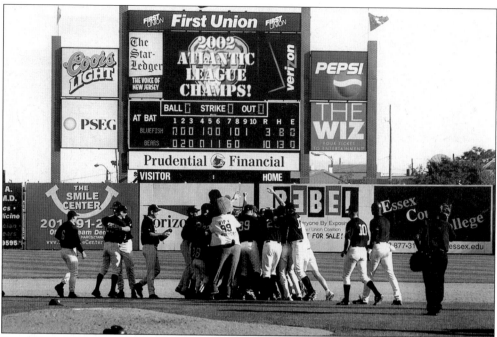

Bears fans and players celebrate after winning the Atlantic League Championship on September 22, 2002. The Bears defeated the Bridgeport Bluefish 10-3 to capture Newark's first professional title in more than 50 years. (Photograph by Kyle Burke.)

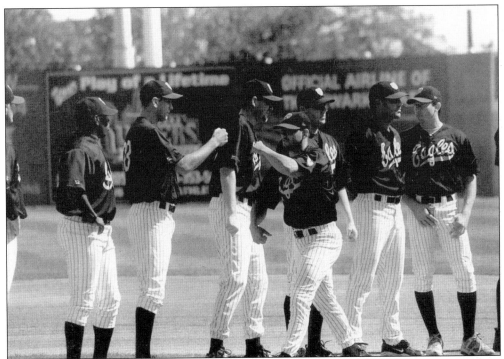

During the 2002 season, Newark honored the memory of the Eagles by wearing that team's uniforms and honored the Bears by returning to Yankee pinstripes. (Photographs by Colin and Kyle Burke.)

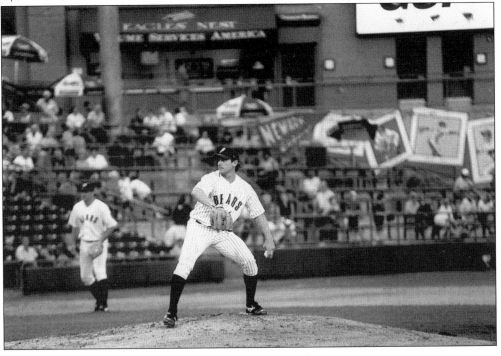

Larry Doby, former Newark Eagle and member of the Professional Baseball Hall of Fame, helped Bears owner Rick Crone rededicate Riverfront Stadium as Bears and Eagles Riverfront Stadium in 2001. "In 1946 and 1947 the Bears and the Eagles couldn't play each other despite the city's getting along well together," Doby said. "We need to bring Newark back to that community spirit." (Photographs by Colin Burke.)

During pregame ceremonies on opening day in 2003, the remaining members of the previous year's winning team proudly display the league championship trophy.

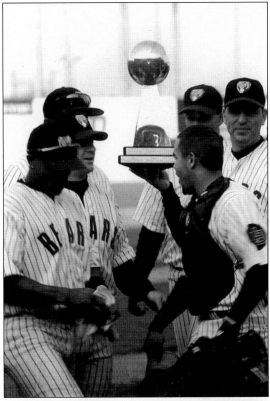

The Bears opened on a cold night in 2003, defeating Bridgeport 6-5. (Photograph by Gordon Forsyth.)

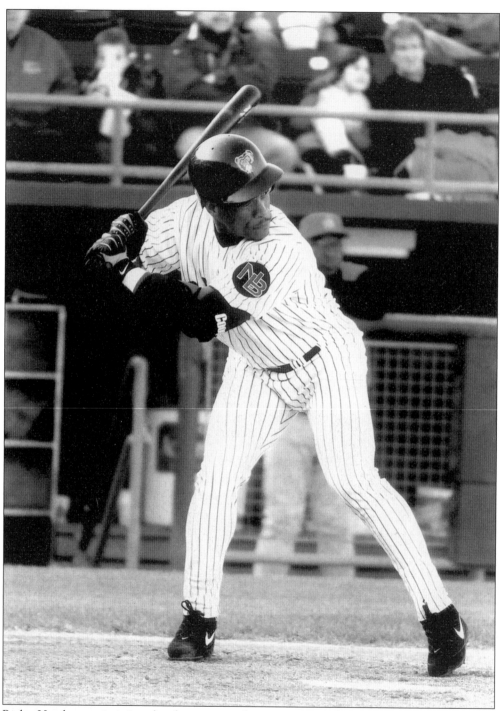

Ricky Henderson, insisting that he was not done yet, returned to professional baseball as a member of the 2003 Bears. His experience has proved invaluable to all his teammates. Upon his arrival in Newark, Henderson commented, "I look around and I see a lot of teams in the gutter. I'm gonna stay around here until somebody up there wants me." (Photograph by Gordon Forsyth.)

Newark fans extended a warm welcome to future Hall of Famer Ricky Henderson. New York *Daily News* sportswriter Bill Madden wrote that baseball's all-time runs, walks, stolen bases, and leadoff home run leader "frolicked" on opening night and, before you could ask him why, Henderson "looks you squarely in the eye and says: 'Why not.' " (Photograph by Gordon Forsyth.)

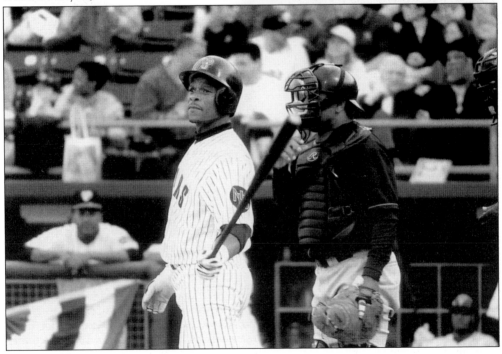

Outfielder Will Quintana is shown here at bat. (Photograph by Gordon Forsyth.)

Pictured here is catcher Jason Torres. (Photograph by Gordon Forsyth.)

Posing together here are hitting coach Tony Ferrara (left), Phil Rizzuto (center), and manager Tom O'Malley. (Courtesy of the Newark Bears.)

Four-time National League batting champion and Bears manager Bill Madlock discusses strategy with first-base coach Hector Tatis. Madlock replaced Marv Foley as skipper in 2003.

Former Cy Young Award winner Mike Cuellar joined the Bears as a pitching coach in 1999. Pete Filson currently handles that position. Filson won his last major-league game in 1987 as a New York Yankee with Bears owner Rick Cerone behind the plate. (Courtesy of the Newark Bears.)

Bill Ashley played for the Bears during the 2001 season and now serves as the team's third-base coach. (Courtesy of the Newark Bears.)

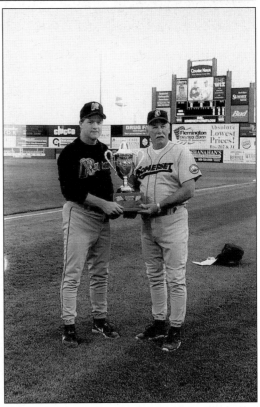

Reminiscent of the Newark–Jersey City rivalry of the 1930s and 1940s, the Bears and Somerset Patriots compete against each other for the Network Sharing Cup and the state's bragging rights in the Atlantic League. Patriots manager and former pitching ace Sparky Lyle joins Bears manager Tom O'Malley in displaying the coveted trophy. (Photograph by Colin Burke.)

Rip'n Ruppert delights fans during the games, especially members of the Bears fan club. According to legend, Rip'n was found in 1998 hibernating in the Ironbound section of Newark, not far from old Ruppert Stadium. (Photograph by Gordon Forsyth.)

Jerry Izenberg, the dean of all New Jersey sportswriters, grew up watching the Bears and listening to Earl Harper's play-by-play on the radio. His role in reviving the spirit of baseball in Newark remains unequaled. His *Star-Ledger* columns welcoming the team back to the city are the best source of information and inspiration on the team's historic comeback. (Courtesy of the Newark Bears.)

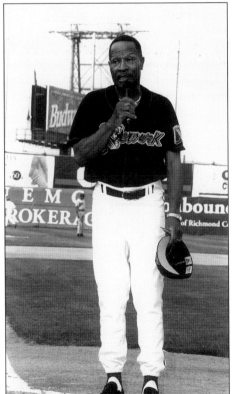

Mayor Sharpe James, pictured here, played an instrumental role in bringing the Bears back to the city. Commenting on the historical significance of the team's return, Mayor James remarked, "Let history say that we started with two separate teams. Now we will have a team that will mirror both the Eagles and the [former] Bears, brought about by black and white, Republican and Democrat, urban and suburban, athlete and non-athlete." (Photograph by Bill Lenahan.)

Baseball, but especially minor-league baseball, is about kids and community. Throughout the years, the old Bears, the Eagles, and the new Bears have shaped the identity of Newark and created a sense of place for its entire people. (Courtesy of the Newark Bears.)

Mayor Sharpe James recognized the importance of minor-league baseball and the presence of Bears and Eagles Riverfront Stadium when he remarked, "It's about a place that moms and dads and kids can afford to go on a summer night. It's about a place where people can come together, where race doesn't matter, but the home team does." Baseball did not always have the courage to transcend divides, but the current Bears are making it work.

BIBLIOGRAPHY

Cunningham, John. *Baseball in New Jersey: The Game of History*. Trenton: New Jersey State Museum, 1995.

Cvornyek, Robert. "Your Bears to Our Bears: Race, Memory, and Professional Baseball in Newark New Jersey." *The Cooperstown Symposium on Baseball and American Culture, 2001*. Jefferson: McFarland, 2002.

DiClerico, James M., and Barry J. Pavelec. *The Jersey Game: The History of Modern Baseball from Its Birth to the Big Leagues in the Garden State*. New Brunswick: Rutgers University Press, 1991.

Holway, John. *The Complete Book of Baseball's Negro Leagues: The Other Half of Baseball History*. Fern Park: Hastings House, 2001.

———. *Voices From the Great Black Baseball Leagues*. New York: Dodd, Mead, and Company, 1975.

Izenberg, Jerry. "A Great Baseball Town Reawakens." *Newark Star Ledger*, July 16, 1999.

Kirsch, George B. *Baseball in Blue and Grey: The National Pastime during the Civil War*. Princeton: Princeton University Press, 2003.

Linthurst, Randolph. *Newark Bears*. Trenton: White Eagle, 1978.

———. *Newark Bears: The Middle Years*. self-published, 1979.

———. *Newark Bears: The Final Years*. self-published, 1981.

Mayer, Ronald A. *The 1937 Newark Bears: A Baseball Legend*. New Brunswick: Rutgers University Press, 1994.

Overmeyer, James. *Queen of the Negro Leagues: Effa Manley and the Newark Eagles*. Lanham: Scarecrow Press, 1998.

Peterson, Robert. *Only the Ball Was White: A History of Legendary Black Players and All-Black Professional Teams*. New York: Oxford University Press, 1992.

Riley, James A. *The Biographical Encyclopedia of the Negro Baseball Leagues*. New York: Carroll and Graf, 1994.

Sullivan, Neil J. *The Minors: The Struggles and the Triumph of Baseball's Poor Relation from 1876 to the Present*. New York: St. Martin's Press, 1990.

Sumner, Benjamin Barrett. *Minor League Baseball Standings: All North American Leagues, through 1999*. Jefferson: McFarland, 2000.